GAME OF THRONES™

THE NOBLE HOUSES OF WESTEROS

SEASONS 1–5

RUNNING PRESS
PHILADELPHIA · LONDON

Published by Running Press,
A Member of the Perseus Books Group

Printed in China

Books published by Running Press are available at special discounts for bulk purchases in the United States by corporations, institutions, and other organizations. For more information, please contact the Special Markets Department at the Perseus Books Group, 2300 Chestnut Street, Suite 200, Philadelphia, PA 19103, or call (800) 810-4145, ext. 5000, or e-mail special.markets@perseusbooks.com.

ISBN 978-0-7624-5797-7
Library of Congress Control Number: 2015945859

E-book ISBN 978-0-7624-5802-8

9 8 7 6 5 4 3 2 1
Digit on the right indicates the number of this printing

Game of Thrones series photographs by principal unit photographer, Helen Sloan.
Additional photography by unit photographers Macall Polay, Nick Briggs, Keith Bernstein, and Paul Schiraldi.

Designed by Joshua McDonnell
Edited by Cindy De La Hoz
Typography: Gotham, and Trajan

Running Press Book Publishers
2300 Chestnut Street
Philadelphia, PA 19103-4371

Visit us on the web!
www.runningpress.com

Contents

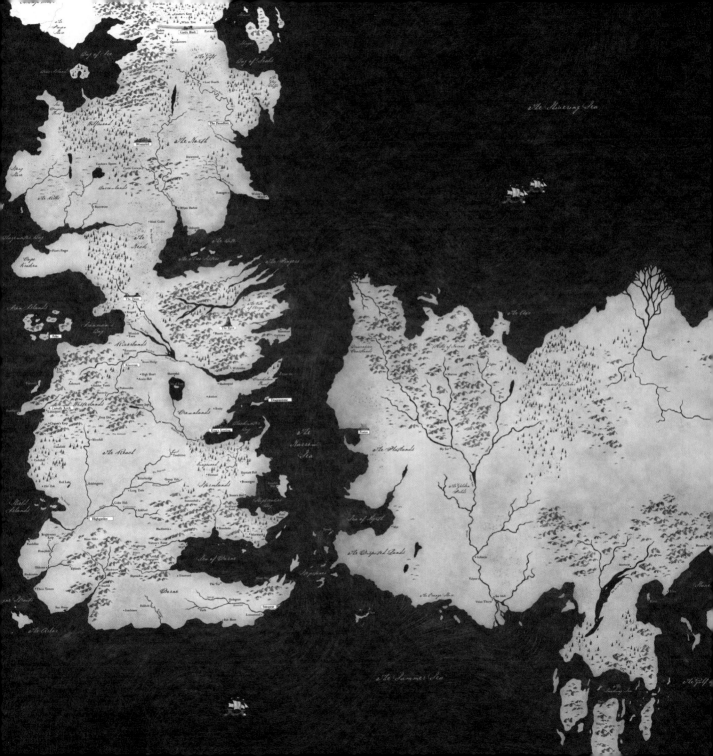

Introduction

In the seven kingdoms of Westeros, an intricate and perilous game is being played out among its participants, the great and noble houses. This book is intended to serve as a guide to the key houses as their constant struggle for power persists and as the hierarchical structure of the kingdom evolves. Alliances are formed, wars are waged, kings are murdered and new monarchs are crowned. After all, in the *Game of Thrones*, you either win or you die.

HOUSE STARK

WINTER IS COMING

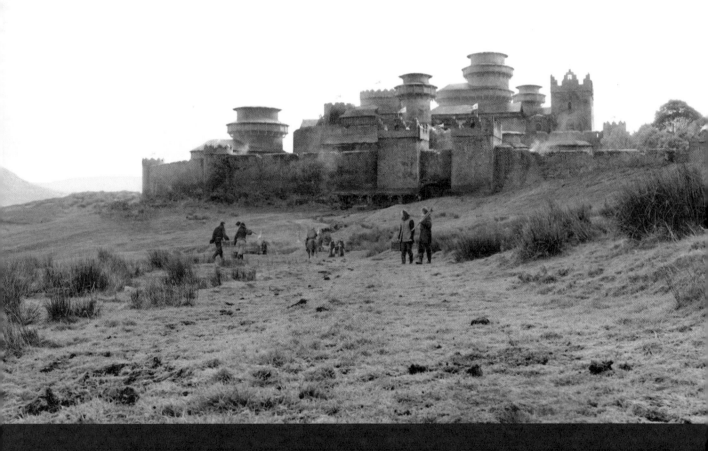

SEAT: NONE, FORMERLY WINTERFELL **REGION:** THE NORTH

Winterfell was the seat of the Stark family for generations until one-time Stark ward Theon Greyjoy seized the castle for his father during the War of Five Kings. Roose Bolton's bastard son, Ramsay Snow, took it from the Greyjoys but left it in ruins. Tywin Lannister awarded the castle to Lord Bolton after the Red Wedding for

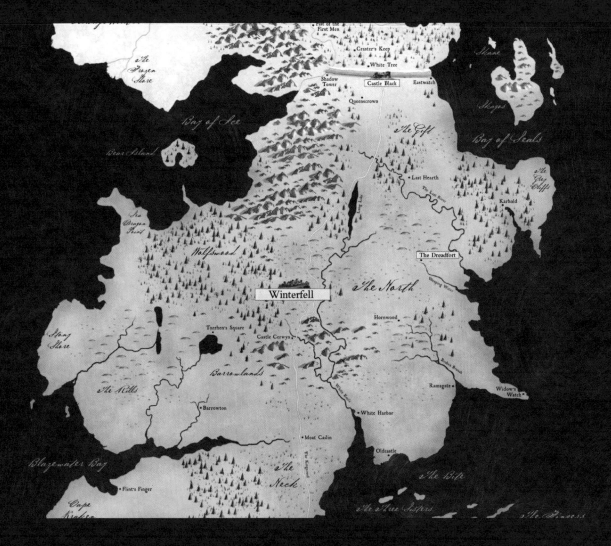

HISTORY

The leading house of the North, the Starks reigned as Kings in the North until the Targaryen conquest, after which they served as the region's warden for nearly 300 years. Following the execution of his father, Robb Stark severed ties with King's Landing and declared himself King in the North. That bid for independence came to a violent halt when Walder Frey and Roose Bolton murdered Robb and Catelyn Stark at a massacre known as the Red Wedding. In an alliance arranged by Lord Petyr Baelish, Sansa Stark returned to Winterfell and married Ramsay Bolton.

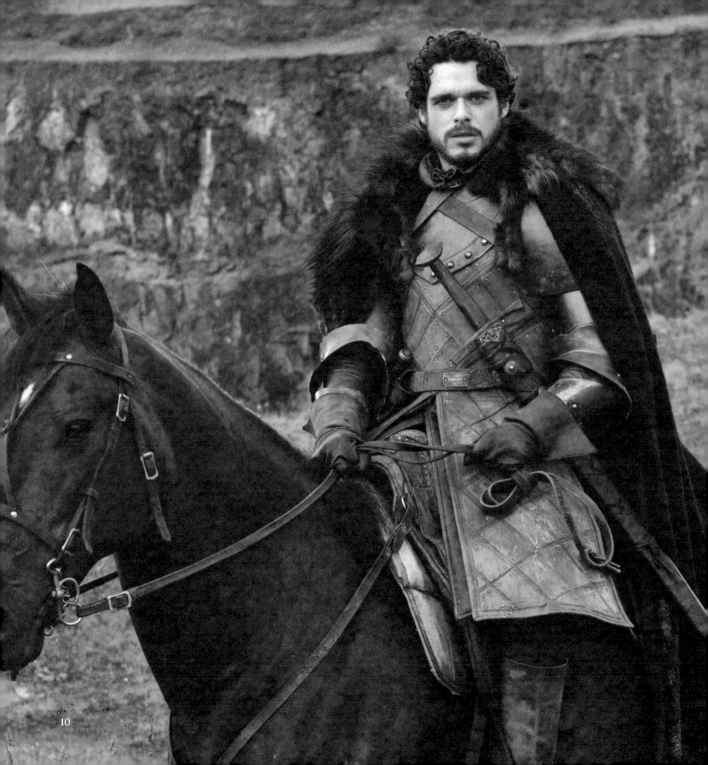

Family Tree

RICKARD
STARK

CATELYN
STARK

EDDARD
STARK

LYANNA
STARK

BENJEN
STARK

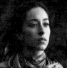

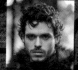

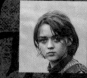

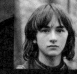

TALISA
STARK

ROBB
STARK

SANSA
STARK

ARYA
STARK

BRAN
STARK

RICKON
STARK

JON
SNOW

Household

LUWIN

RODRIK
CASSEL

HODOR

OSHA

BRIENNE
TARTH

JOJEN
REED

MEERA
REED

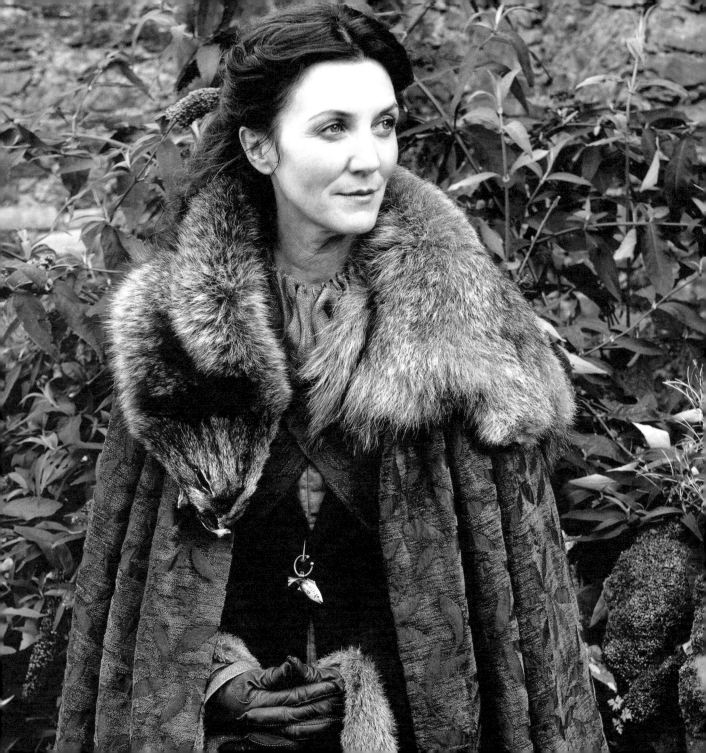

THE FAMILY

RICKARD STARK

During his post as Lord of Winterfell, Rickard Stark arranged the marriages of his son Brandon to Catelyn Tully, and his daughter Lyanna to Robert Baratheon. Both engagements foundered when Rhaegar Targaryen stole off with Lyanna, thus initiating a series of events that resulted in the executions of both Rickard and Brandon at the command of King Aerys Targaryen, the Mad King.

BRANDON STARK

The firstborn son of Rickard Stark, Brandon was preparing for his wedding to Catelyn Tully when he received news that his sister Lyanna had been abducted by Raegar Targaryen. He and his father were executed by the king, Aerys Targaryen, after a failed attempt to bring Raegar to justice.

EDDARD "NED" STARK

Stoic, duty-bound and honorable, Ned Stark embodied the values of the north. In moving to King's Landing to serve as Hand to his longtime friend Robert Baratheon, Ned fell on the wrong side of court intrigues and paid for it with his life.

CATELYN STARK

Catelyn married Ned Stark after King Aerys executed Ned's brother, Brandon, to whom Catelyn was betrothed. Though she and Ned barely knew each other at the time of their wedding, their love grew strong over the years. After Ned's death, Catelyn tried to reunite her scattered family, but she was murdered along with her son Robb at the Twins.

THE FAMILY

LYANNA STARK

Although she was engaged to Robert Baratheon, Lyanna Stark never lived to marry him. Her abduction by Rhaegar Targaryen, heir to the throne, was one of several reasons Ned Stark and Robert Baratheon raised arms against the Mad King Aerys. She died in Ned's arms during his attempt to rescue her; Robert mourned her death even after he wed Cersei Lannister.

BENJEN STARK

Ned's younger brother and First Ranger of the Night's Watch, Benjen Stark is also a hero of Jon Snow. He never returned from a ranging expedition.

JON SNOW

Ned Stark's bastard son, Jon joined the Night's Watch where he served as steward to Lord Commander Mormont. He was himself elected Lord Commander of the Watch with the support of his friends Sam Tarly and Maester Aemon. During his tenure, Jon made the unpopular decision to ally with the wildlings and save them from the White Walkers. For that he was murdered at Castle Black by his own men, including Alliser Thorne and Olly.

TALISA STARK

Although a highborn lady of Volantis, Talisa trained in the medical arts. After a short and passionate courtship, she and Robb Stark were married, breaking a promise Robb had made to Walder Frey. Talisa, Robb, and Robb's mother Catelyn were subsequently murdered by a vengeful Lord Walder, who was acting in service of Tywin Lannister.

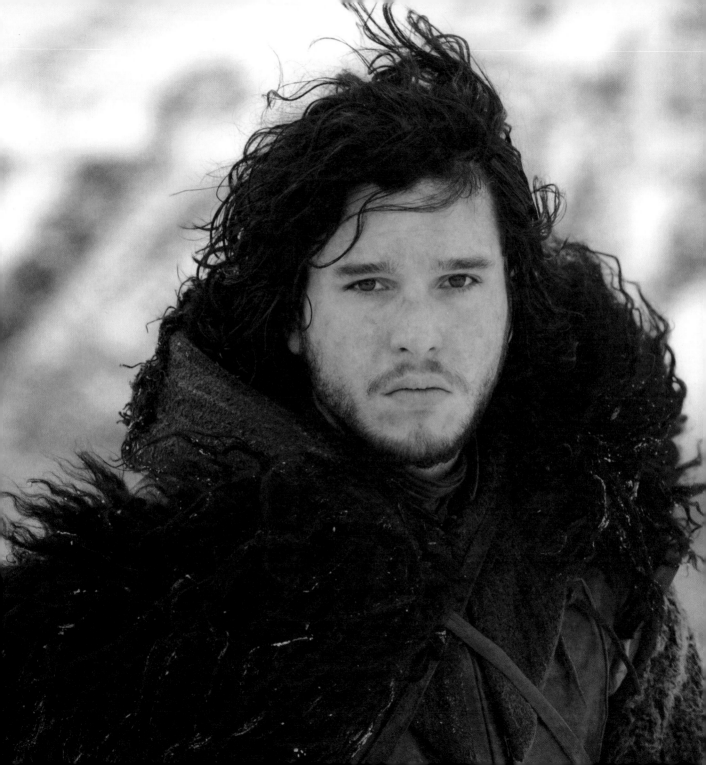

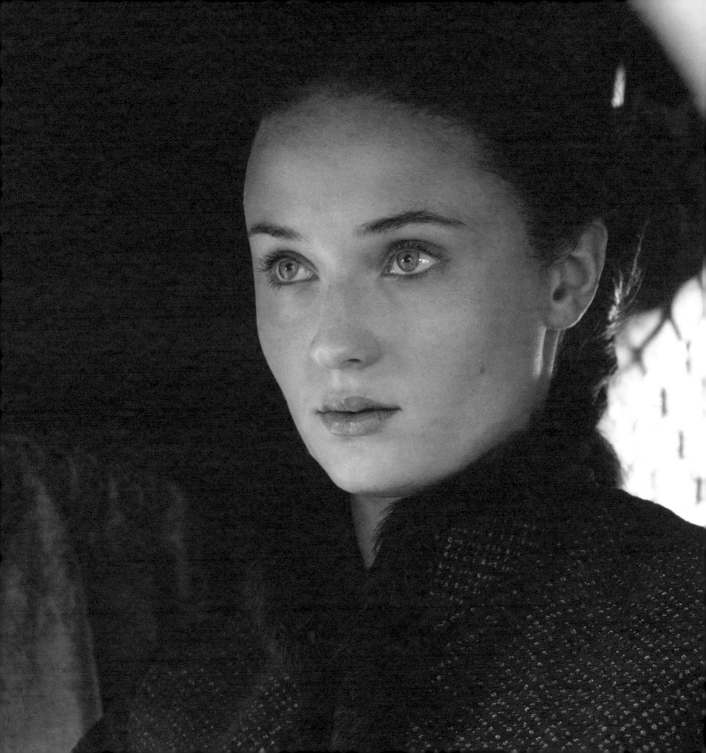

THE FAMILY

ROBB STARK

As Lord of Winterfell and then King in the North, Robb always upheld the responsibilities that came with his titles. Robb's one lapse was marrying Talisa Maegyr when he was already engaged to marry a Frey. In retaliation, Lord Walder Frey orchestrated the murders of Robb, his wife, and his mother Catelyn, while playing host to the Starks at his daughter's wedding.

SANSA STARK

Sansa's naïveté didn't help her in King's Landing, where her former fiancé, Joffrey Baratheon, routinely abused her. After her engagement to Joffrey was dissolved, Sansa was married to his uncle Tyrion Lannister, who treated her with the utmost respect. She fled to the Eyrie with Littlefinger's help after Joffrey's murder and protected him after the death of her aunt Lysa. Littlefinger returned Sansa to Winterfell, where she married Ramsay Bolton. During Stannis Baratheon's failed attack on the castle, she and Theon Greyjoy leapt from a castle wall in an attempt to escape.

ARYA STARK

Presumed dead by most of Westeros, Arya cherishes a mental list of all those she desires dead in return, as vengeance for herself and her family. After the deaths of her father, mother, brother, and aunt, Arya sailed east to restart her life in Braavos. She located her protector from Harrenhal, Jaqen H'ghar, at the House of Black and White. Unable to forsake her past life as the Faceless Men demand, Arya murdered Meryn Trant when she spotted him in Braavos. She was rendered blind as a punishment.

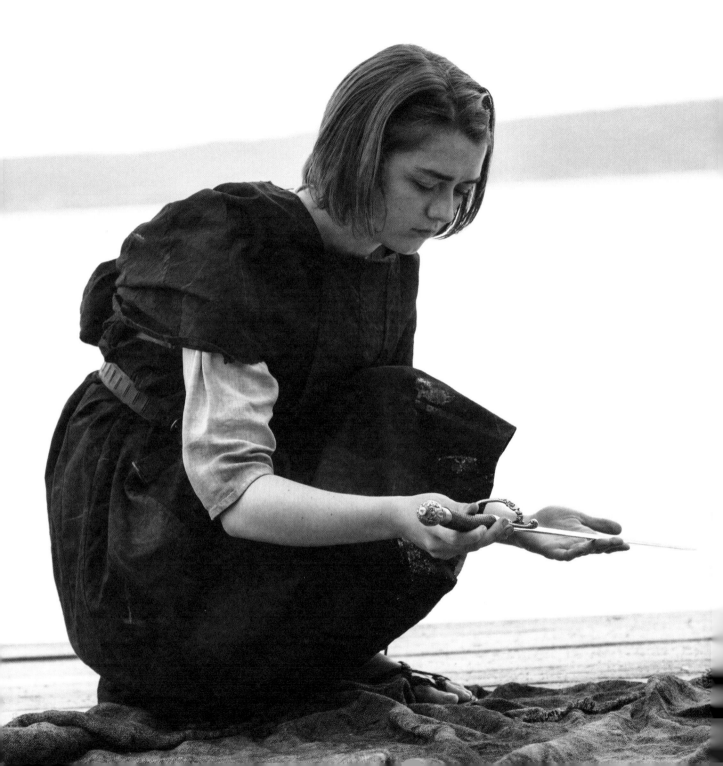

THE FAMILY

BRAN STARK

Although crippled in a fall, Bran Stark runs free as his direwolf when he dreams. Having escaped the sack of Winterfell with his brother Rickon, Hodor, and Osha, Bran headed north with Hodor to fulfill the visions that he shared with Jojen Reed. Jojen did not survive the journey, but Bran was able to locate the Three-Eyed Raven.

RICKON STARK

Rickon is the youngest of the Stark children. He and Bran escaped the sack of Winterfell and are now traveling north, along with Osha, Hodor and the Reeds. After the group learned that Castle Black might be under attack, Bran sent Rickon and Osha to Last Hearth for safekeeping. Rickon's direwolf is named Shaggydog.

HOUSEHOLD

LUWIN

Maester of Winterfell, Luwin provided wise counsel to the Starks. He was murdered by Greyjoy men after Theon captured the castle.

RODRIK CASSEL

Winterfell's Master at Arms, Ser Rodrik served as the Starks' primary military and security adviser. He was sloppily beheaded by Theon Greyjoy.

HODOR

A simple-minded stableboy, Hodor serves as Bran's primary means of transport. He is believed to be descended from giants and can only express himself with the single word, "Hodor." He traveled north with Bran.

OSHA

A wildling who was captured after threatening Bran, Osha has since joined the Stark household as a servant. Along with Hodor, she traveled north with Bran, Rickon and the Reeds until Bran sent her to escort Rickon to Last Hearth.

BRIENNE TARTH

Lord Selwyn of Tarth's daughter, Brienne is a highborn lady who trained instead to be a warrior. Despite Lady Catelyn's death, Brienne was tasked by Jaime to uphold their oath to Catelyn by finding and protecting her daughters. Although both girls refused her help, she followed Sansa to Winterfell all the same and was present when Stannis Baratheon tried to take the castle. Knowing that Stannis was responsible for the death of his brother Renly, whom she served and loved, Brienne killed Stannis.

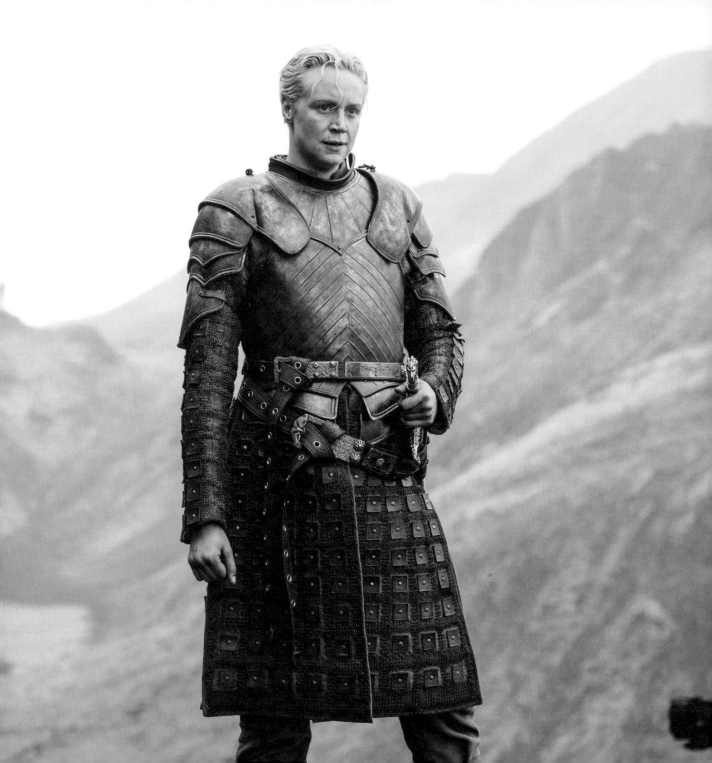

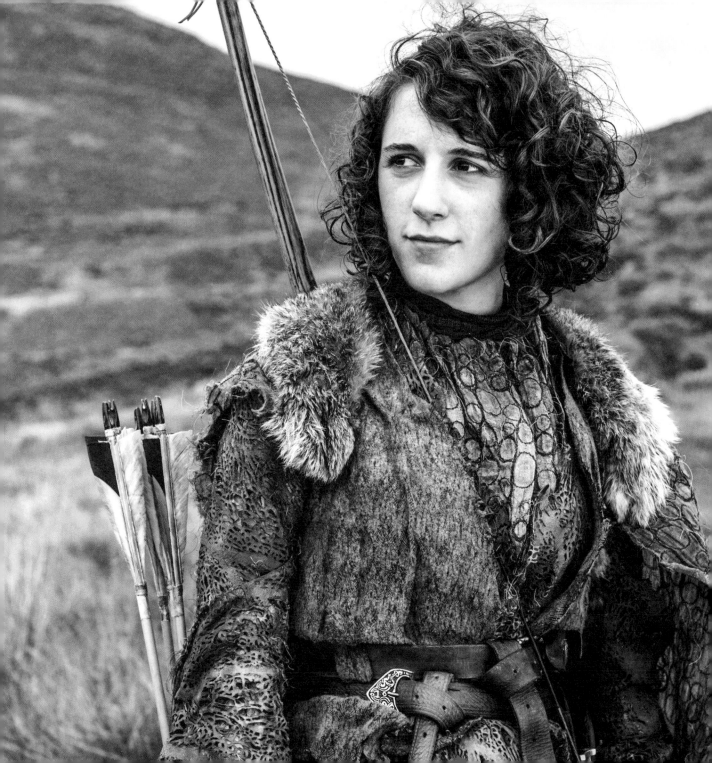

HOUSEHOLD

JOJEN REED

The only son of Howland Reed, lord of Greywater Watch who fought alongside Ned Stark during Robert's Rebellion, Jojen experienced visions similar to Bran Stark's. Despite the careful protection of his sister Meera, Jojen was killed in a wight attack while traveling with Bran and his sister beyond the Wall.

MEERA REED

The oldest child of Howland Reed, Meera is as skilled hunter. She was fiercely protective of her frail younger brother, Jojen, who was killed in a wight attack while the siblings and Bran traveled beyond the Wall.

WEAPON: JON SNOW'S LONGCLAW

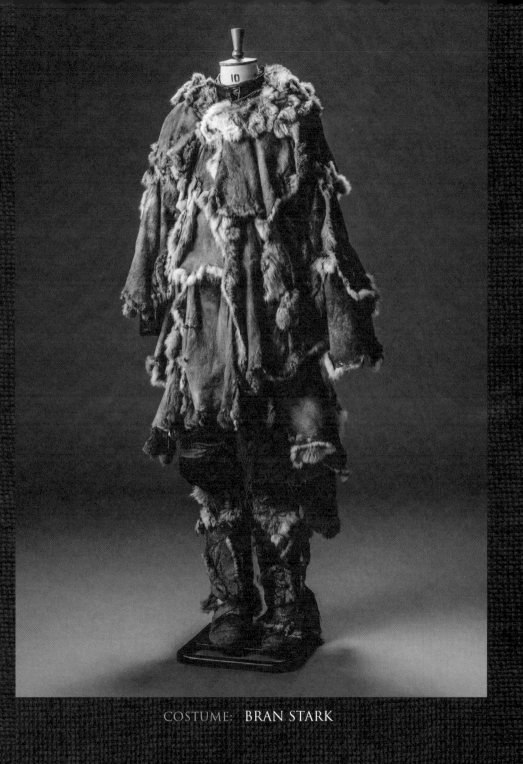

COSTUME: BRAN STARK

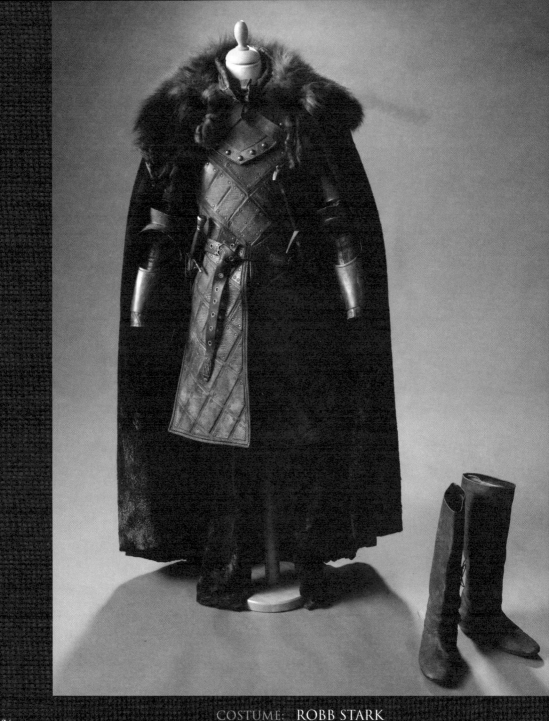

COSTUME: ROBB STARK

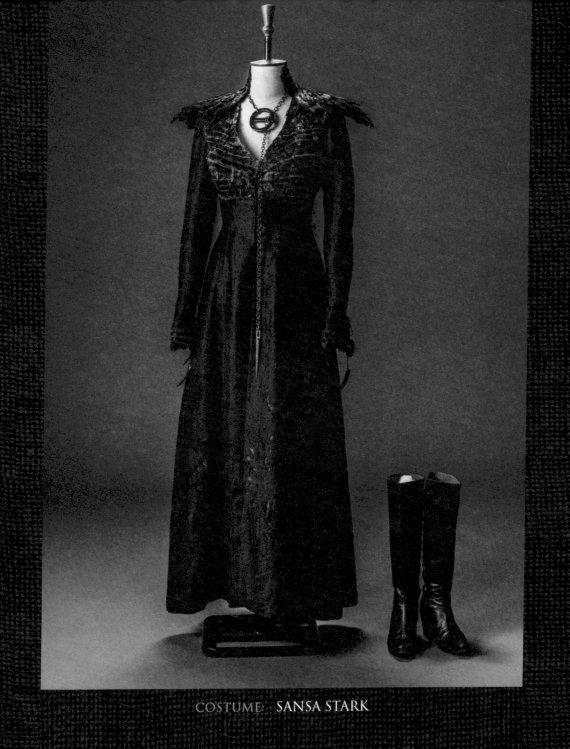

COSTUME: SANSA STARK

HOUSE LANNISTER

Hear
me
Roar

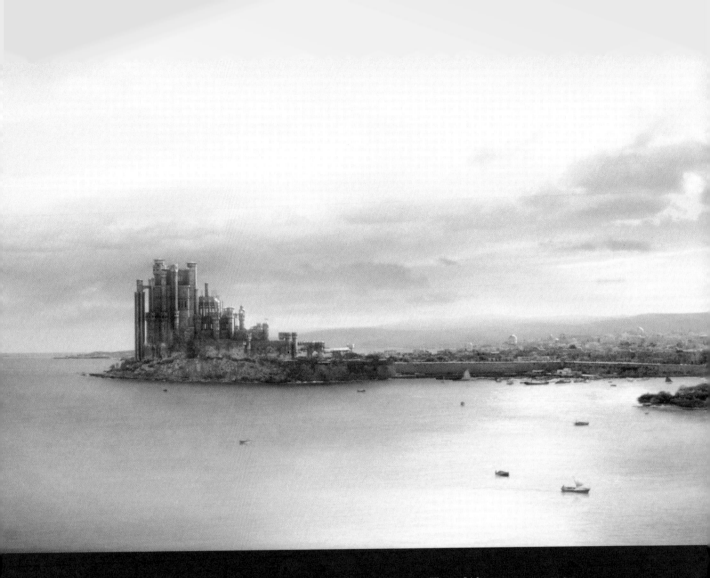

SEAT: **CASTERLY ROCK** REGION: **THE WESTERLANDS**

Legend has it that Lann the Clever tricked the Casterly family into giving up their castle, thus beginning the Lannister bloodline. The fortress guards a region once rife with gold mines, the source of the Lannister's

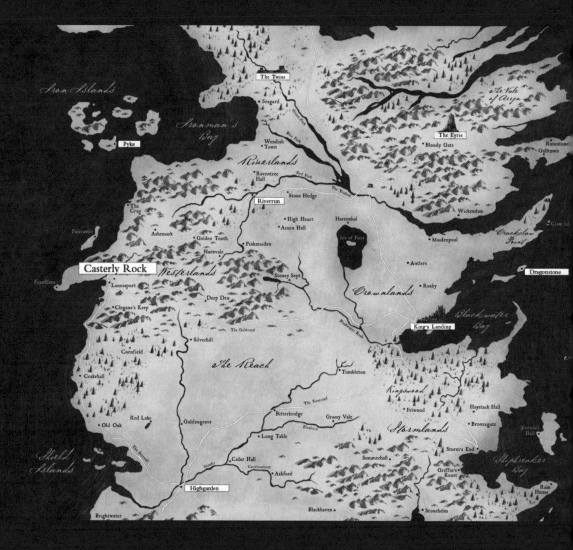

HISTORY

The wealthiest family in Westeros, the Lannisters of Casterly Rock ruled as kings in their realm until the Targaryen dragons conquered the continent. Cersei Lannister's marriage to King Robert Baratheon brought the family to King's Landing; and her son Joffrey's ascendance to the Iron Throne solidified their power.

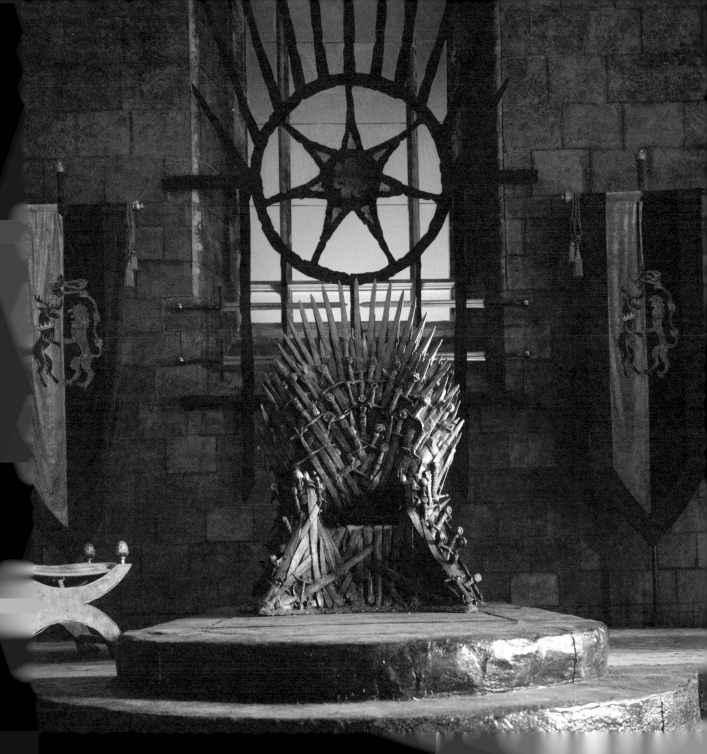

Family Tree

JOANNA
LANNISTER

TYWIN
LANNISTER

KEVAN
LANNISTER

DORNA
LANNISTER

CERSEI
LANNISTER

ROBERT
BARATHEON

JAIME
LANNISTER

TYRION
LANNISTER

LANCEL
LANNISTER

JOFFREY
BARATHEON

MYRCELLA
BARATHEON

TOMMEN
BARATHEON

MARGAERY
TYRELL

Household

GREGOR
"THE MOUNTAIN"
CLEGANE

AMORY
LORCH

BRONN

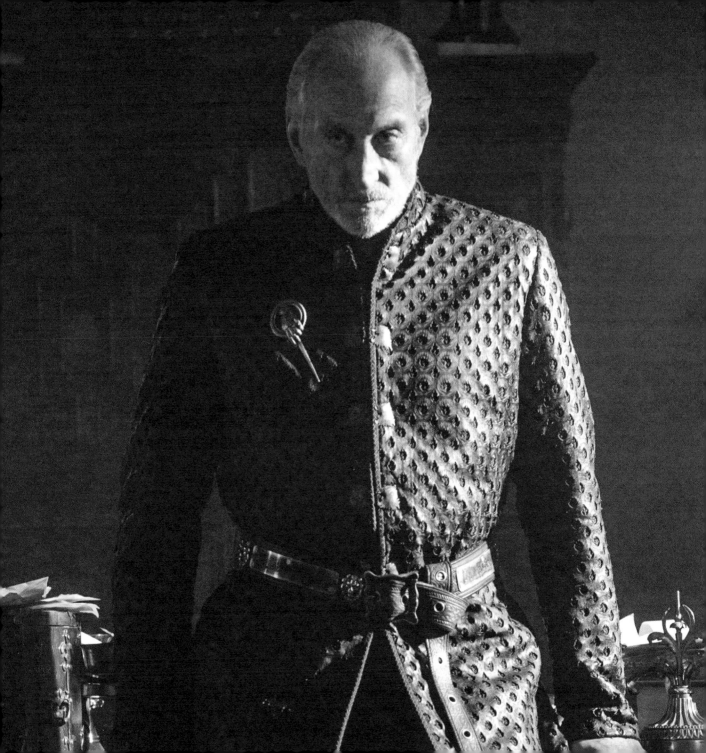

THE FAMILY

TYWIN LANNISTER

As Hand to Aerys Targaryen and the richest man in Westeros, Tywin was believed to be the kingdom's real ruler, an assumption that angered the Mad King. Tywin returned to King's Landing to serve as Hand to his grandsons when they assumed the throne and became the de facto ruler of the kingdom. He was killed by his son Tyrion during Tyrion's escape from King's Landing.

KEVAN LANNISTER

As the younger brother of Lord Tywin Lannister, Kevan had long understood he could not compete with the powerful lord. Instead, he did his duty as a loyal supporter and stood out for his wise and candid counsel.

CERSEI BARATHEON

The only daughter of Tywin Lannister, Cersei was involved in an incestuous relationship with her twin brother Jaime even before she was married off to Robert Baratheon. Cersei's plan to empower the Faith Militant backfired when she herself was imprisoned and accused both of murdering Robert and of incest—though not with Jaime but with her cousin Lancel. Cersei finally confessed to this one crime only, and was forced to atone by walking naked and in shame back to the Red Keep.

JAIME LANNISTER

The twin brother of Queen Cersei, Jaime is plagued by his nickname, "The Kingslayer," which he earned after killing the Mad King during Robert's Rebellion. Jaime gained a friend in Brienne of Tarth during their journey back to King's Landing, but he lost his sword hand along the way. After his brother Tyrion was convicted of murdering King Joffrey, Jaime helped Tyrion escape, inadvertently allowing Tyrion to confront and kill their father. Jaime sailed to Dorne to return Princess Myrcella to King's Landing; she acknowledged him as her father before dying of poison in his arms.

THE FAMILY

TYRION LANNISTER

As acting Hand of the King, it was Tyrion who hatched the plan that saved King's Landing from Stannis Baratheon's attack. Tyrion married Sansa Stark at his father's insistence, but always treated her with the utmost respect. Convicted of murdering his nephew King Joffrey, Tyrion escaped execution with help from his brother Jaime, and fled King's Landing after killing his former lover Shae and his father. Tyrion found his way to Meereen with Jorah Mormont to serve Daenerys Targaryen. With Dany missing, he remains in the city to rule in her stead.

LANCEL LANNISTER

First cousin and a former lover of Cersei Lannister, Lancel served as Robert Baratheon's squire. He swore himself to the Faith of the Seven after suffering a grave injury during the Battle of the Blackwater. After Littlefinger told Olenna of Lancel's past activities, she used the information to force Lancel to confess his sins to the High Sparrow, who then had Cersei imprisoned.

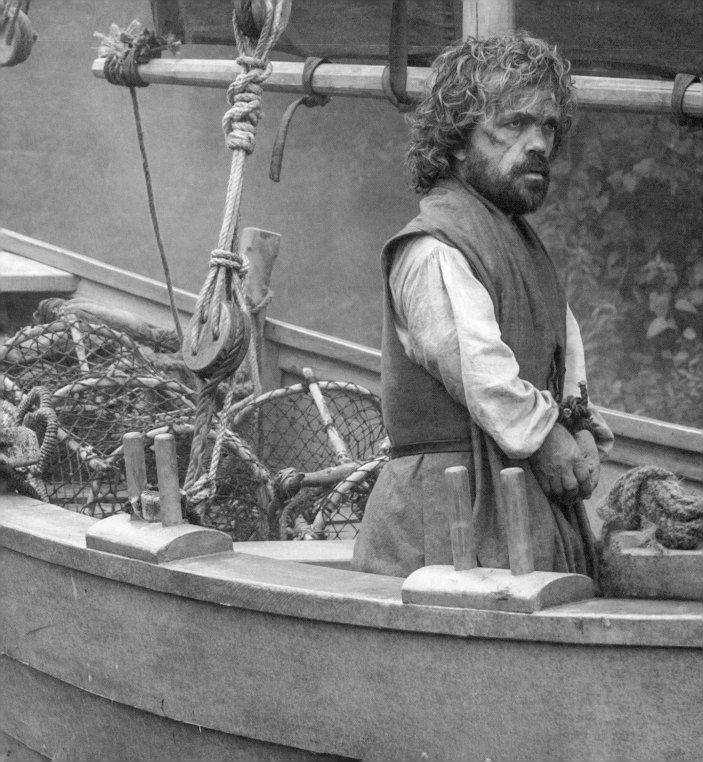

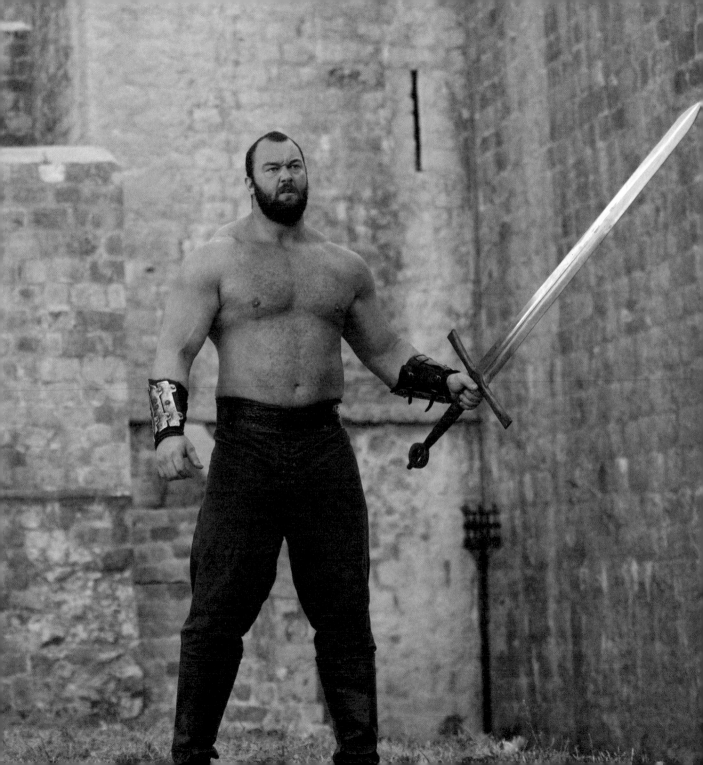

HOUSEHOLD

Gregor "The Mountain" Clegane

A massive knight who stands more than seven feet tall, Ser Gregor Clegane is known as "The Mountain That Rides." He has served the Lannisters as a vicious thug along with his brother, Sandor Clegane, but the two bear no love for each other. During the wartime sack of King's Landing, Gregor raped and murdered Elia, wife of Prince Rhaegar, and killed their two young children. Gregor was critically injured and poisoned by Oberyn Martell during Tyrion Lannister's trial by combat, and is now being treated by Qyburn.

Amory Lorch

A Lannister bannerman, Ser Amory caught Arya Stark stealing correspondence at Harrenhal. To protect herself, Arya gave Amory's name to Jaquen H'ghar, who promptly killed him.

Bronn

A sellsword who fought on behalf of Tyrion Lannister, Bronn was knighted for his bravery during the Battle of Blackwater and remained in Tyrion's service until Tyrion was accused of killing his nephew King Joffrey. Cersei bought Bronn's loyalty by offering him an engagement to Lady Lollys Stokeworth, and her family's castle. Bronn's marriage has been thwarted by Jaime Lannister, who enticed Bronn to travel with him to Dorne to rescue Princess Myrcella—as well as recoup his own fortunes.

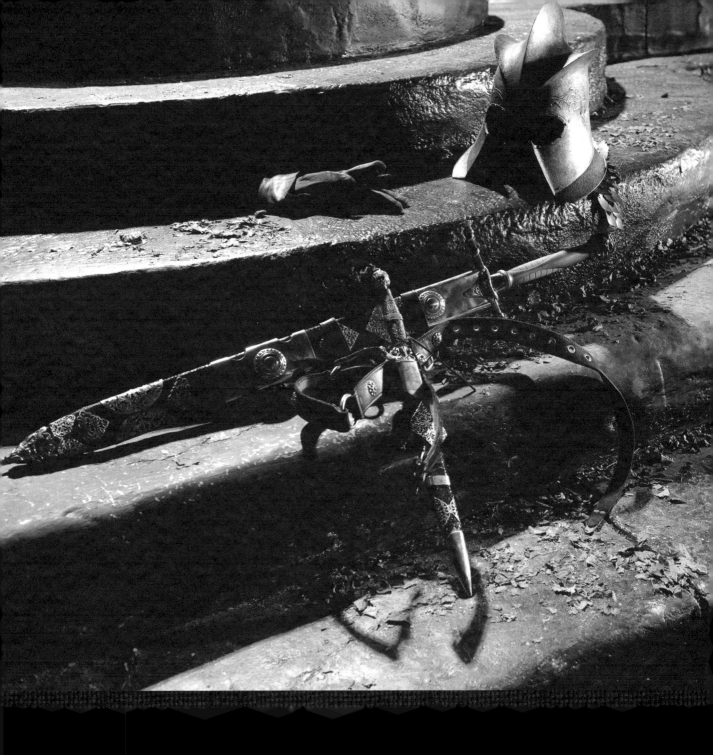

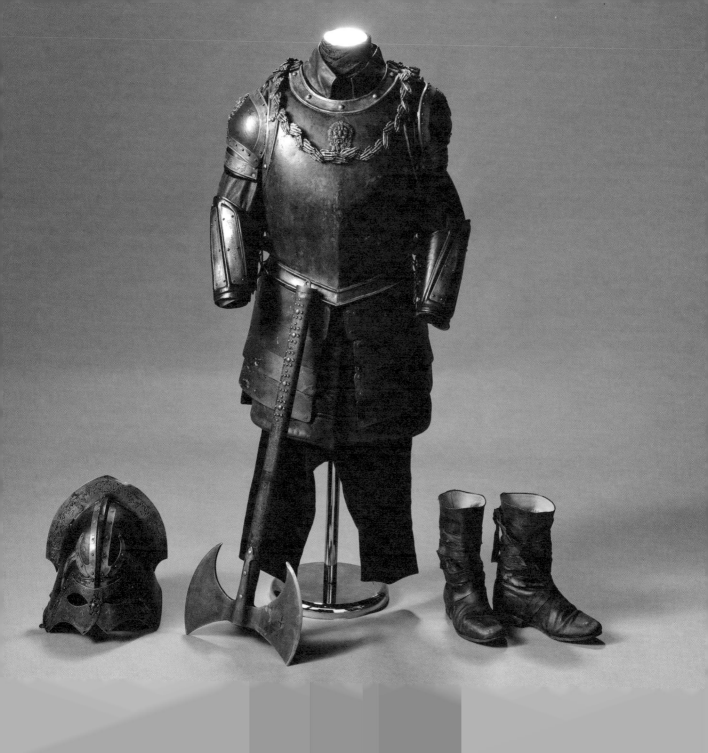

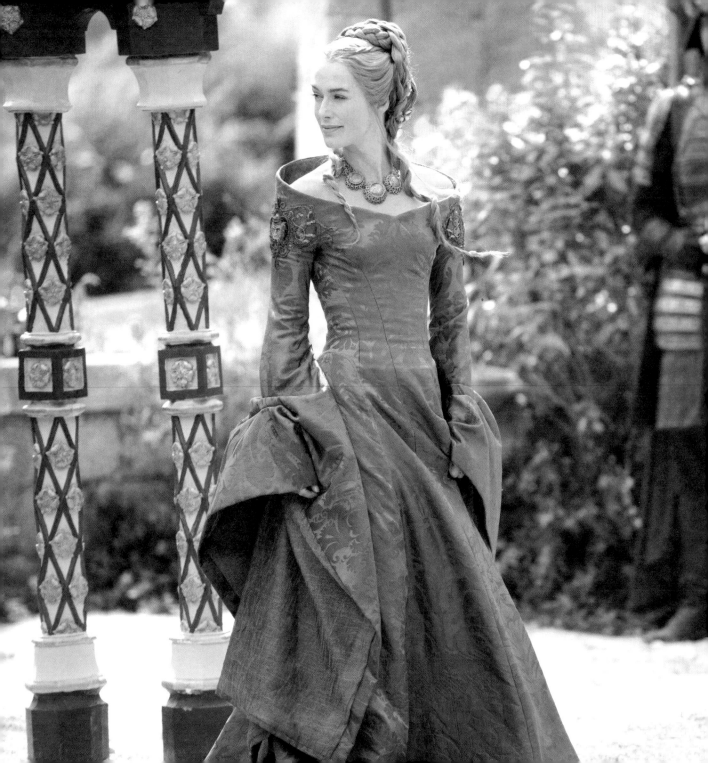

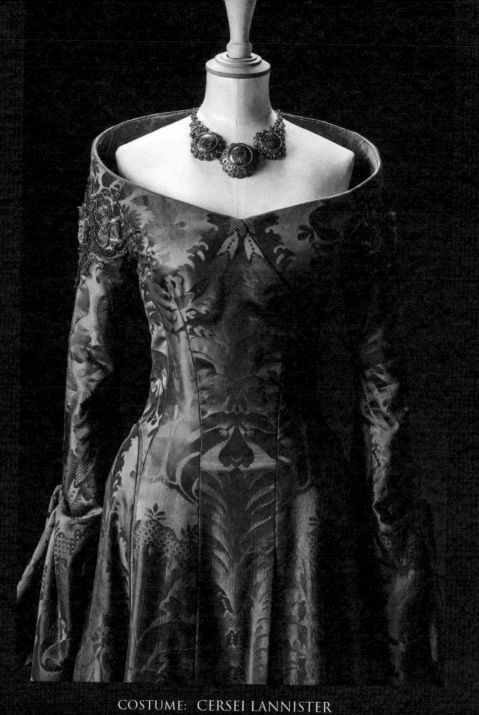

COSTUME: CERSEI LANNISTER

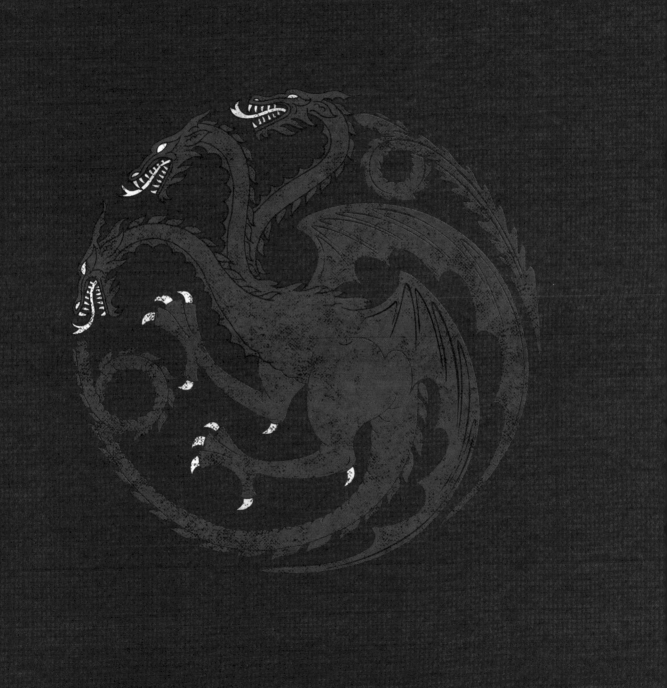

HOUSE TARGARYEN

Fire
and
Blood

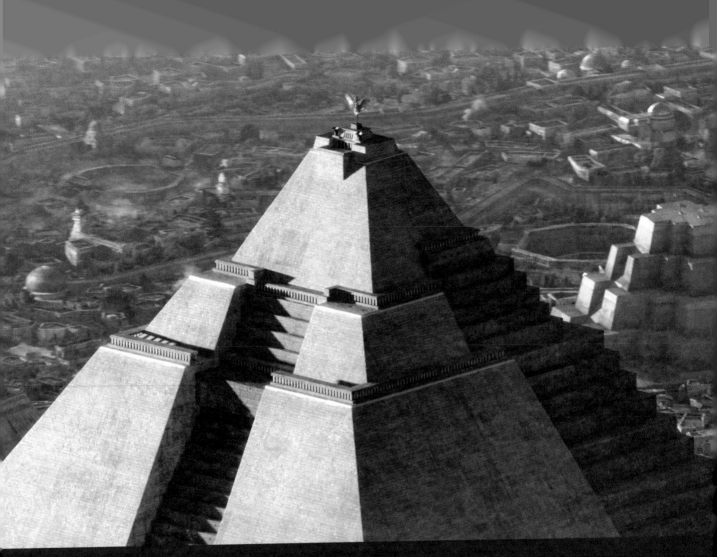

SEAT: MEEREEN, FORMERLY DRAGONSTONE **REGION:** SLAVER'S BAY, FORMERLY THE CROWNLANDS

The greatest city in Slaver's Bay, Meereen boasted a thriving slave trade until the arrival of Daenerys Targaryen. Dany incited a slave rebellion and took the city with the backing of her army of Unsullied. Her rule was challenged by the Sons of the Harpy, who nearly assassinated Dany before she fled to Meereen riding Drogon. Tyrion Lannister manages the city in her absence with vital assistance from Missandei and Grey

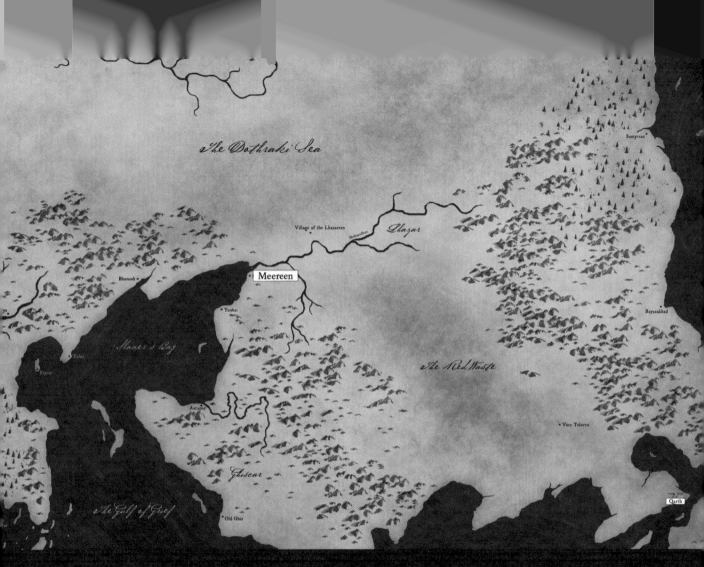

HISTORY

The Targaryens came from the ancient civilization of Valyria, bringing dragons from the eastern continent and settling on the island of Dragonstone. After a mysterious disaster known as the Doom of Valyria wiped out their homeland and killed most of the world's dragons, the Targaryens invaded Westeros. A rebellion eliminated most of the royal family and cost them the kingdom, but from her exile in Essos, Daenerys

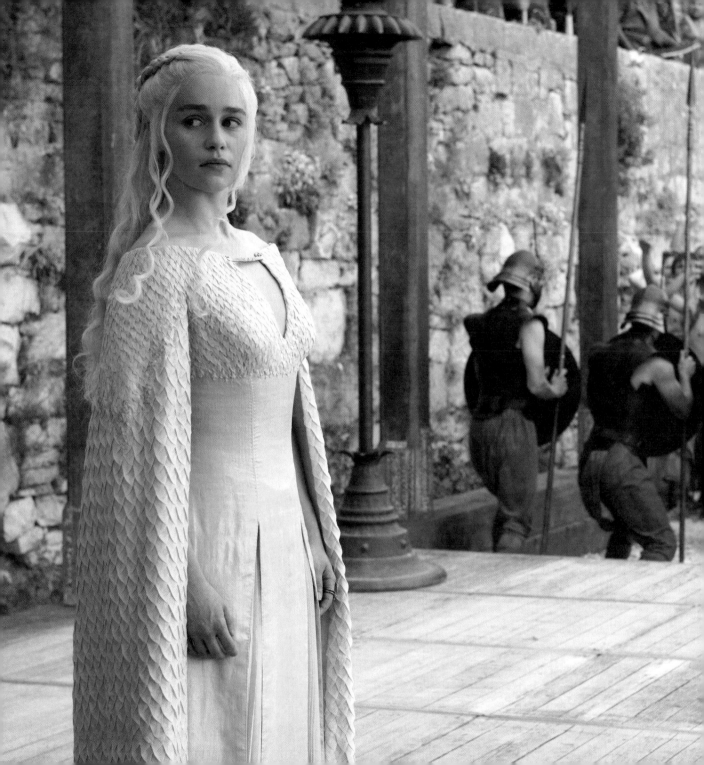

AERYS II
TARGARYEN

RHAELLA
TARGARYEN

AEMON

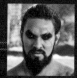

ELIA
MARTELL

RHAEGAR
TARGARYEN

VISERYS
TARGARYEN

DAENERYS
TARGARYEN

DROGO

RHAENYS
TARGARYEN

AEGON
TARGARYEN

DROGON

RHAEGAL

VISERION

ADVISORS AND SUPPORTERS

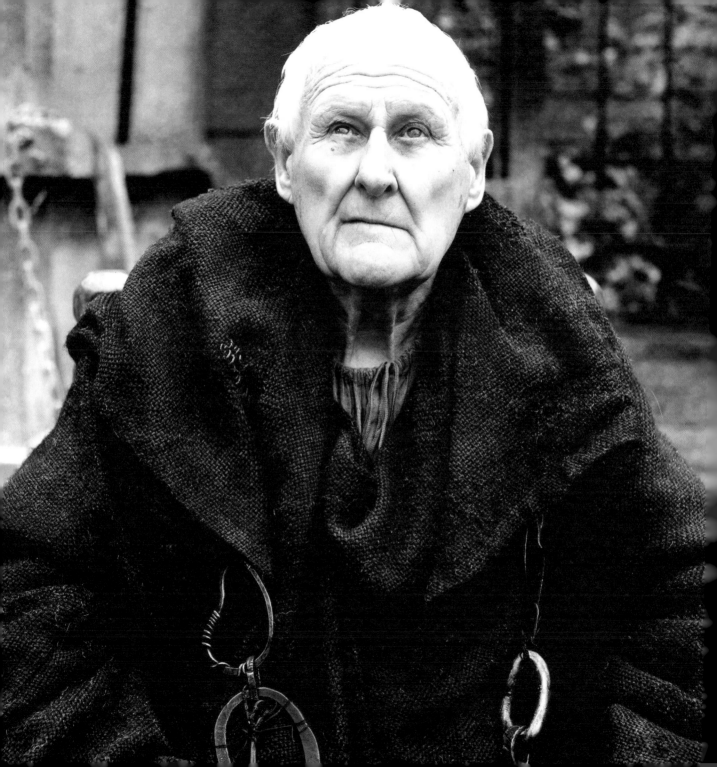

THE FAMILY

AERYS II TARGARYEN

The last of the Targaryens to reign, Aerys was known as the Mad King due to his unpredictable temper. Instead of ransoming Brandon Stark and his companions to their fathers as he'd promised, Aerys murdered everyone in full sight of his court, thus inciting Ned Stark and Robert Baratheon to take up arms against him.

RHAELLA TARGARYEN

The sister of King Aerys Targaryen, Rhaella followed the Targaryen tradition and married her brother to preserve "the blood of the dragon." After Aerys was killed during the sack of King's Landing, Rhaella fled with her son Viserys to Dragonstone where she gave birth to her daughter Daenerys. After Rhaella's death, the children escaped to Essos to live in exile.

AEMON

The longtime maester of the Night's Watch, Aemon was blind but sharp. One of the last remaining Targaryens, Aemon understood the brothers of the Watch left their family ties behind. Fond of both Sam Tarly and Jon Snow, it was Aemon who cast the deciding vote that made Jon the 998th Lord Commander of the Night's Watch.

RHAEGAR TARGARYEN

The heir to the Targaryen throne, Rhaegar began the feud between the Starks and the Targaryens by riding off with Ned Stark's sister, Lyanna. Robert Baratheon, affianced to Lyanna, slew Rhaegar in hand-to-hand combat at the Battle of the Trident.

THE FAMILY

VISERYS TARGARYEN

The only surviving male heir of House Targaryen, the young Viserys was sent with his newborn sister Daenerys to Essos to live in safety. In exile he grew obsessed with retaking his family's throne, but Khal Drogo executed him with a crown of molten gold before he could claim his post as king.

DAENERYS TARGARYEN

With the Unsullied of Astapor and the Second Sons under her command, Daenerys liberated Slaver's Bay from thousands of years of bondage. She then decided to remain in Meereen and prove herself as a queen worth following. Although she considers her dragons as her children, she imprisoned two of them when she was presented with the burned bones of a child. Drogon remained free, however, and returned to save Dany when her entourage was besieged at the Fighting Pit of Daznak, whisking her away to the Dothraki Sea.

DROGO

A fierce warrior who led a tribe of horsemen in Essos, Drogo had never been defeated in battle until he succumbed to a wound that festered after the meddling of the witch Mirri Maz Duur.

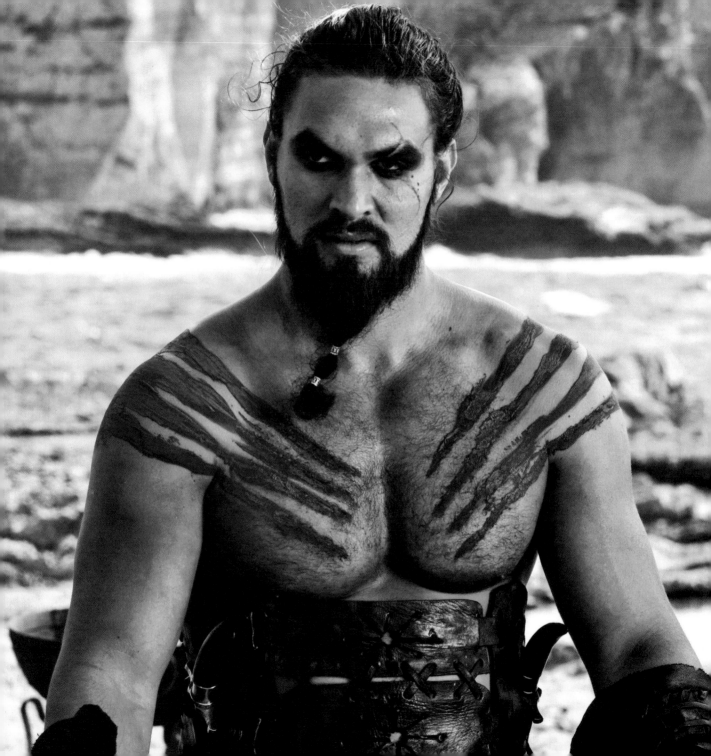

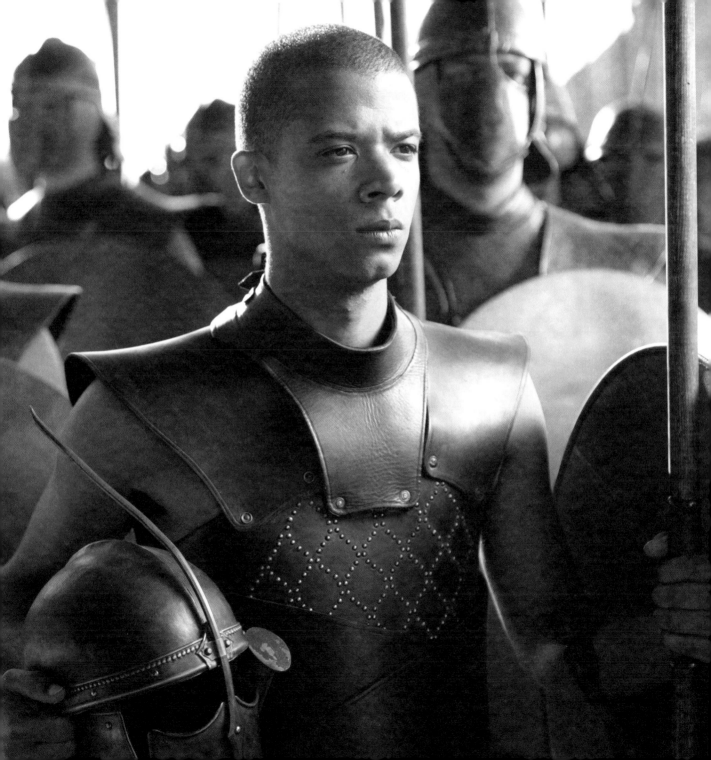

ADVISORS AND SUPPORTERS

BARRISTAN SELMY

Also known as Barristan the Bold, the former Lord Commander of the Kingsguard was the most famous knight in Westeros until King Joffrey dismissed him. Ser Barristan then sought out Daenerys to fulfill the oath he swore to the Targaryens when he still served Dany's father, the Mad King. Trusted advisor and Lord Commander of Dany's Queensguard, he was killed in Meereen by the Sons of the Harpy.

MISSANDEI

A former slave girl in Astapor, Missandei is fluent in the Common Tongue and High Valyrian, among other languages. Impressed by her demeanor, Daenerys took on the girl's services as a translator and came to trust her for advice as well. Missandei developed feelings for Grey Worm and nursed him back to health after he was injured fighting the Sons of the Harpy. She remains with him in Meereen to lend legitimacy to Tyrion's rule of the city.

GREY WORM

Grey Worm is the leader of the highly trained Unsullied fighters from Astapor who accompanied Daenerys Targaryen to Meereen. Seriously injured while policing the city against the Sons of the Harpy, he was nursed back to health by Missandei. The two remain in Meereen to lend legitimacy to Tyrion's rule of the city.

DAARIO NAHARIS

Daario was a lieutenant with the Second Sons, sellswords hired by the slave masters to defend Yunkai against Daenerys. Originally dispatched to assassinate Dany, he killed his captains and helped her conquer the slave city instead. Daario served Dany as an advisor and lover, and now travels north with Jorah Mormont in search of their queen.

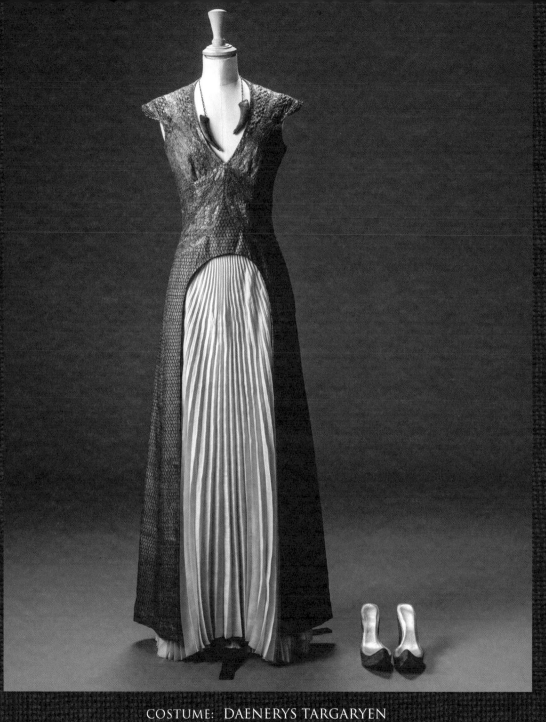

COSTUME: DAENERYS TARGARYEN

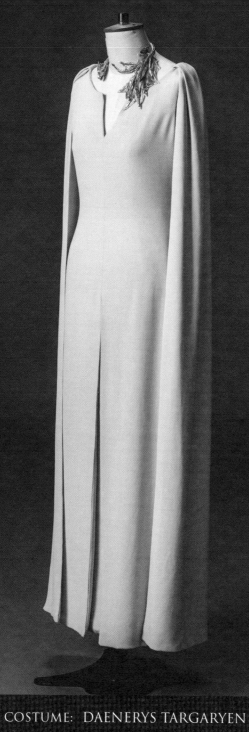

COSTUME: DAENERYS TARGARYEN

HOUSE BARATHEON

STANNIS BARATHEON BRANCH

Ours
is the
Fury

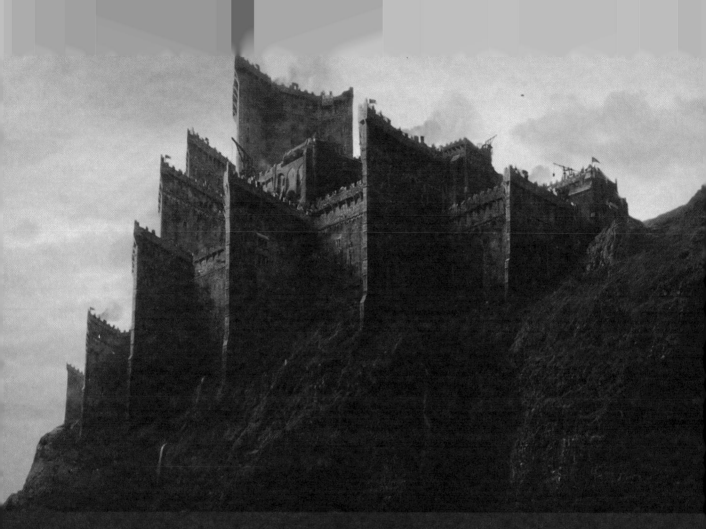

SEAT: **DRAGONSTONE (STANNIS BARATHEON'S CASTLE)** AND **STORM'S END (ANCESTRAL SEAT)**
REGION: CROWNLANDS AND STORMLANDS

When the Targaryen family first arrived in Westeros—long before conquering the continent—they made their home at Dragonstone. Built using Valyrian techniques of stonemasonry, since lost to the ages, the castle looks unlike anything else in this part of the world. After Robert took the throne, he bestowed the keep on his brother Stannis.

The mighty fortress of Storm's End has never fallen to siege or disaster, though it has seen plenty. The coastal castle's seaward wall is 80-feet thick with a 150-foot drop into the waters below. It is said that ancient spells have been woven into the castle's walls, preventing any magic from penetrating its defenses.

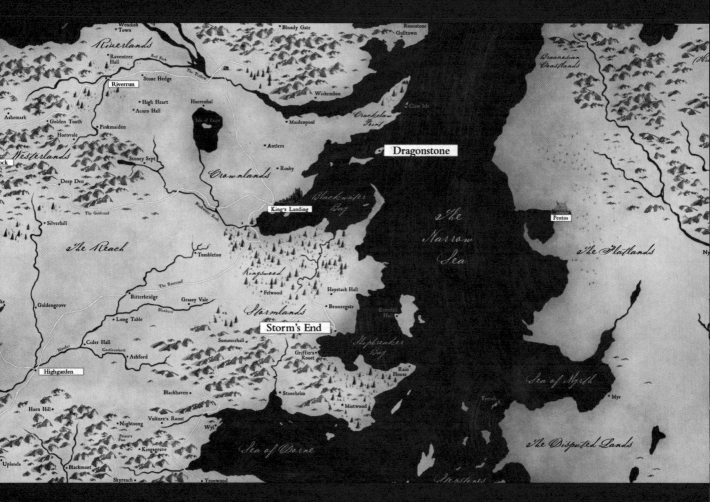

HISTORY

Stannis, who was the last surviving brother of King Robert Baratheon, believed himself to be the true king, a claim supported by the Red priestess Melisandre. House Baratheon, founded after the conquest of Aegon Targaryen, has ruled the Seven Kingdoms since Robert seized the Iron Throne from the Mad King Aerys Targaryen.

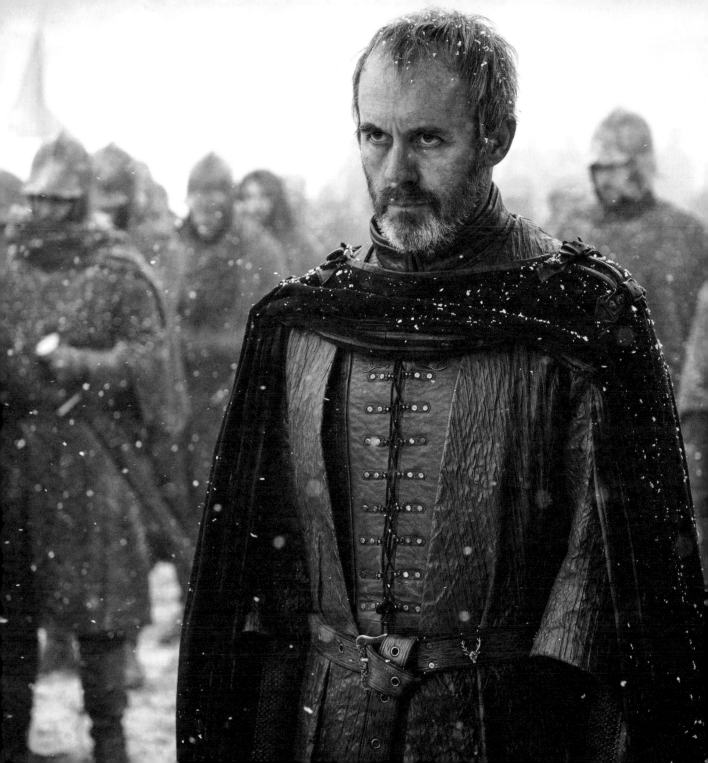

FAMILY TREE

ROBERT
BARATHEON

CERSEI
LANNISTER

STANNIS
BARATHEON

SELYSE
BARATHEON

RENLY
BARATHEON

GENDRY

JOFFREY
BARATHEON

MYRCELLA
BARATHEON

TOMMEN
BARATHEON

MARGAERY
TYRELL

SHIREEN
BARATHEON

COURT

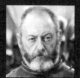
DAVOS

MATTHOS
SEAWORTH

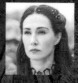
MELISANDRE

CRESSEN

SALLADHOR
SAAN

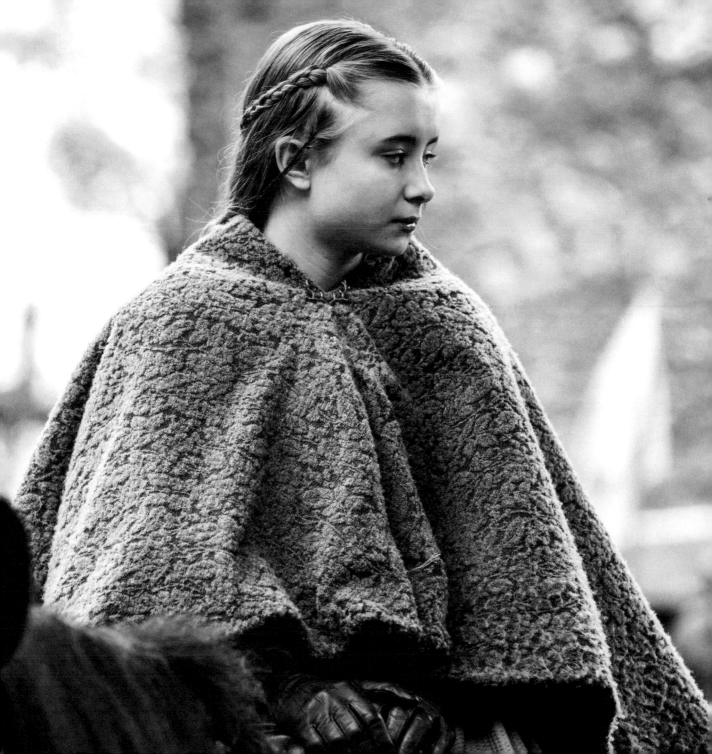

THE FAMILY

STANNIS BARATHEON

One of Robert Baratheon's two younger brothers, Stannis plotted the murder of his brother Renly to rid himself of a rival after Robert's death. At the insistence of the Red Priestess Melisandre, Stannis sacrificed his only child, Shireen, to save his army and cause after snow and a Bolton ambush destroyed his supplies. The decision led to mass desertion in his army and the suicide of his wife, Selyse. Stannis was killed outside of Winterfell by Brienne of Tarth, who wished to avenge Renly's death.

SELYSE BARATHEON

The wife of Stannis Baratheon, Selyse was much more devoted than Stannis to the Lord of Light. She initially supported all of Melisandre exhortations, including sacrificing their only child to help Stannis win the throne. But during Shireen's burning, Selyse had a change of heart. She was found hanging from a tree the day after Shireen's death.

RENLY BARATHEON

The youngest of the three Baratheon brothers, Renly's keen fashion sense and friendly style contributed to his popularity at court. Renly fervently believed he would be a better king than his brother Stannis or his nephew Joffrey, but he didn't live to prove it.

GENDRY

Robert Baratheon's bastard son, Gendry trained as a blacksmith in King's Landing. Upon leaving the city to join the Night's Watch, he met and befriended Arya Stark on the road north. The two separated when Melisandre brought Gendry back to Dragonstone as a sacrifice for Stannis Baratheon. He escaped death when Davos Seaworth set him free.

SHIREEN BARATHEON

Stannis and Selyse's only child, Shireen suffered from disfiguring greyscale at an early age. She was close with her father's Hand, Davos Seaworth, who always had her best interests at heart. Stannis sacrificed Shireen to the Lord of Light at Melisandre's urging.

KING STANNIS'S COURT

DAVOS SEAWORTH

A reformed smuggler who lost the tips of his fingers on one hand as punishment for his previous misdeeds, Davos is also known as "The Onion Knight." He served as Stannis Baratheon's Hand although his opinions often run contrary to those of Melisandre, the Red Priestess who also advises Stannis. Davos returned to Castle Black for more men and provisions at Stannis' request, but was unable to convince his king to let Selyse and Shireen travel with him.

MATTHOS SEAWORTH

Unlike his father, Davos Seaworth, Matthos was a true believer of the Lord of the Light. He died at the Battle of the Blackwater.

MELISANDRE

A Red Priestess from Essos, Melisandre worships the Lord of Light. Her visions have told her that Stannis is the true king, and as his advisor she has encouraged him to pursue the throne at all costs. At her urging, Stannis sacrificed his only child to help turn the war in his favor, only to see further tragedy befall the camp. After Selyse's suicide, Melisandre abandoned Stannis and has returned to Castle Black.

CRESSEN

Maester to Stannis Baratheon, Cressen grew alarmed by Melisandre's increasing influence on Stannis and the king's rejection of the Faith of the Seven. When Cressen tried to poison the Red priestess, he succumbed instead.

SALLADHOR SAAN

A Lysene pirate, Salladhor Saan backed Stannis Baratheon at the urging of his old friend Davos Seaworth, only to abandon the cause after Stannis' defeat at the Blackwater. Flush with funding from the Iron Bank, Davos has once again secured Salladhor's support.

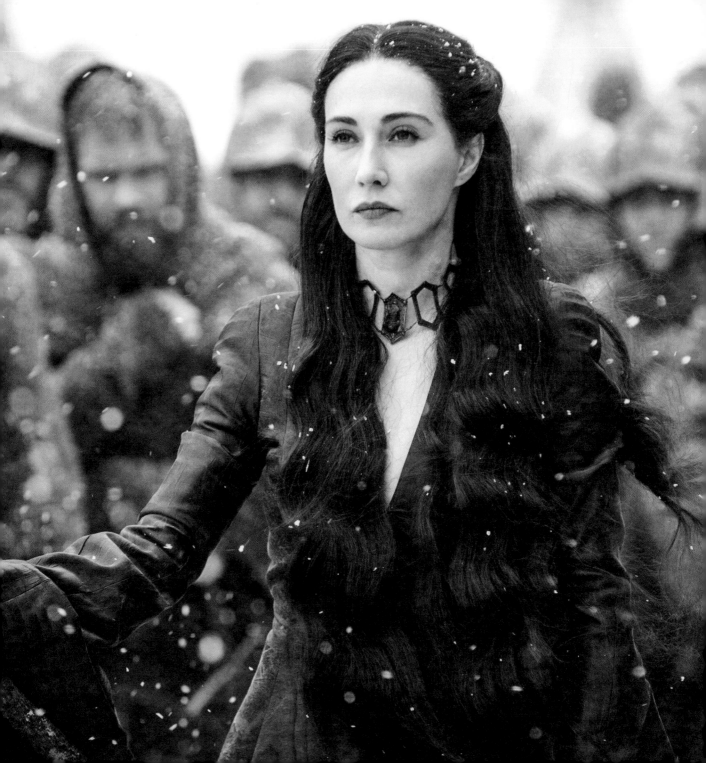

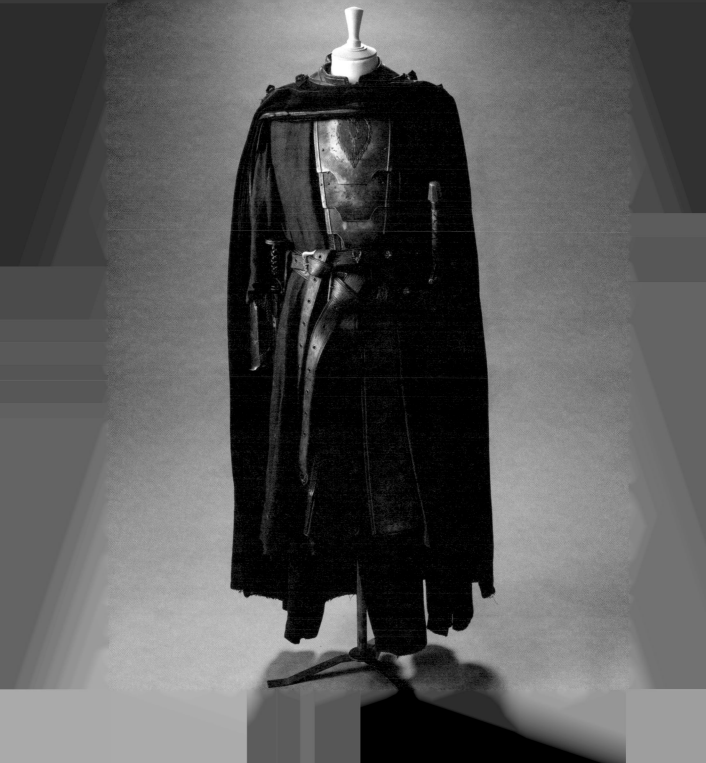

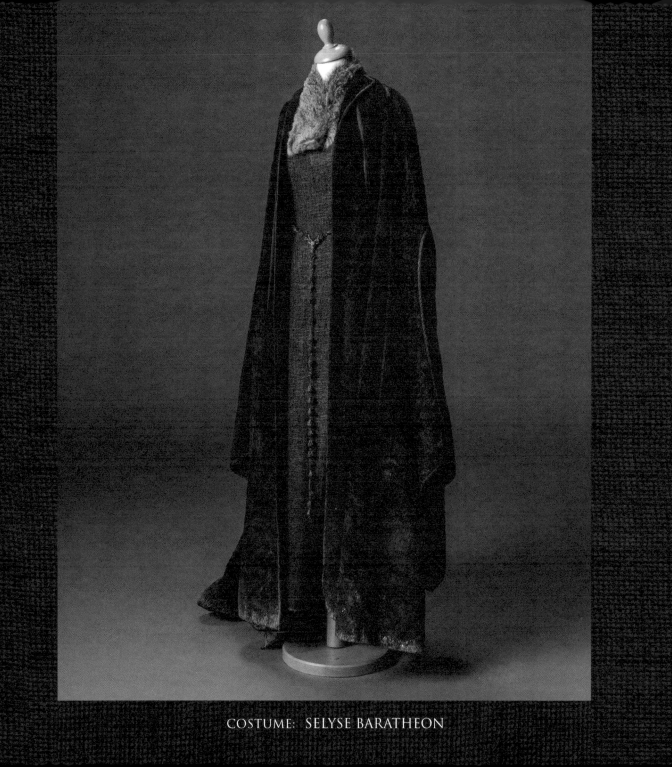

COSTUME: SELYSE BARATHEON

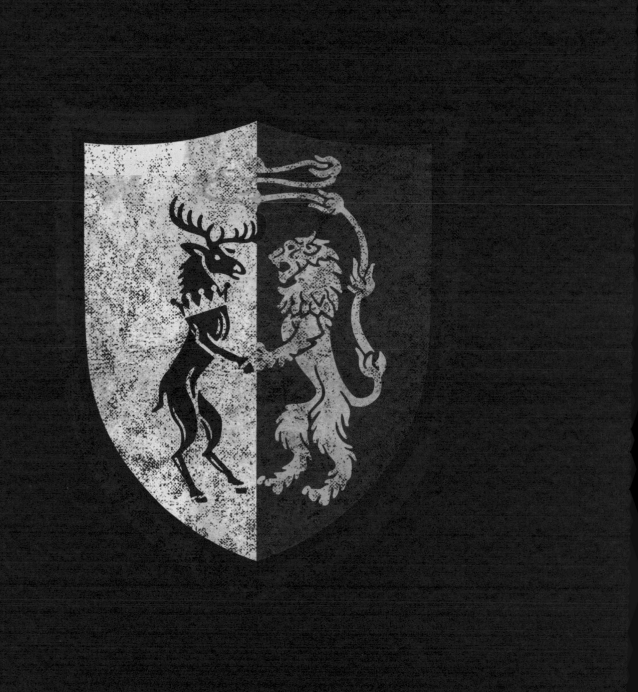

HOUSE BARATHEON

TOMMEN BARATHEON BRANCH

OURS
IS THE
FURY

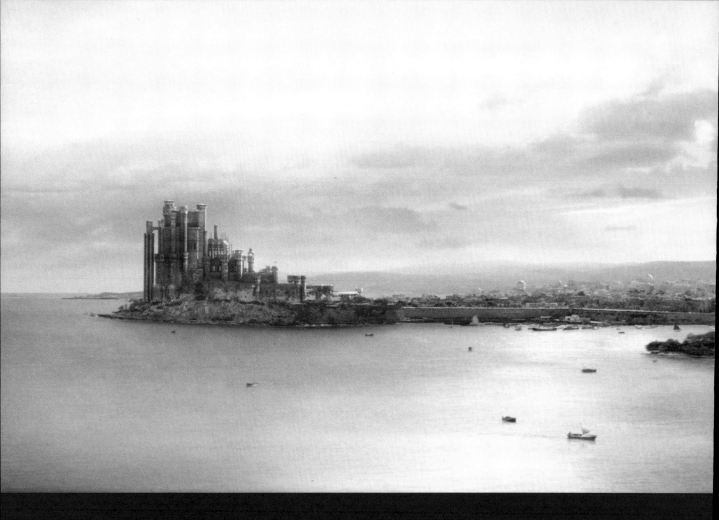

SEAT: KING'S LANDING

REGION: THE SEVEN KINGDOMS OF WESTEROS
(THE REALM)

Named for where Aegon Targaryen "The Conqueror" first landed in Westeros, this city has served as the capital of the Seven Kingdoms ever since. The city is now in the sway of the High Sparrow and the newly empowered Faith Militant.

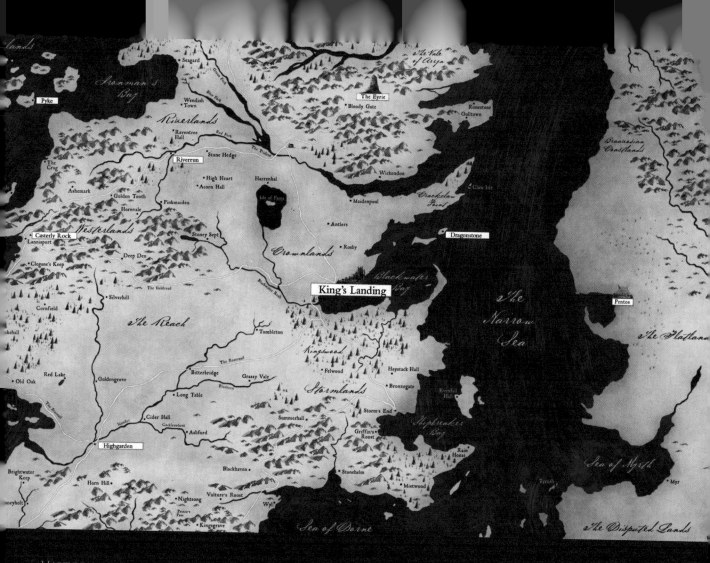

HISTORY

House Baratheon, founded after the conquest of Aegon Targaryen, has ruled the Seven Kingdoms since Robert seized the Iron Throne from the Mad King Aerys Targaryen. Joffrey Baratheon ruled the kingdom

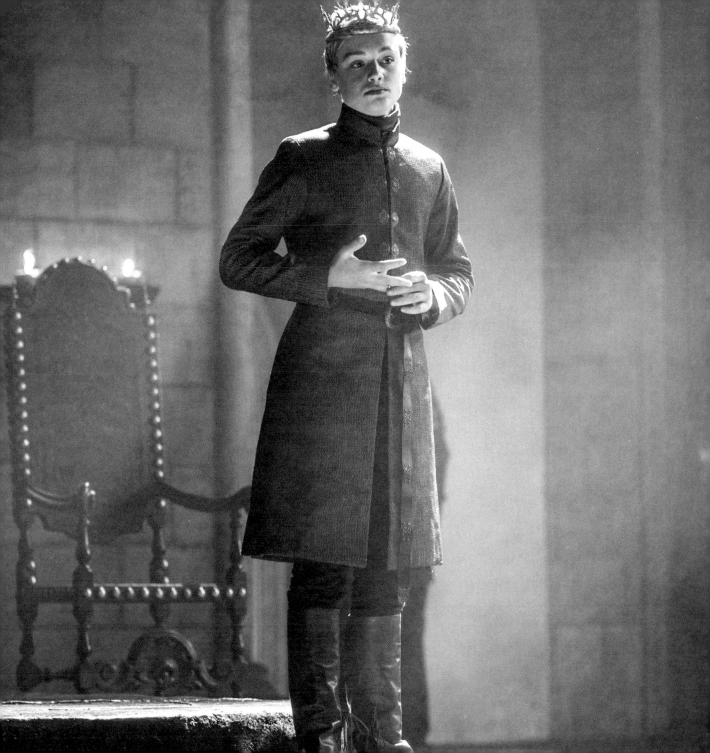

Family Tree

 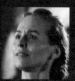 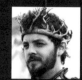

ROBERT
BARATHEON

STANNIS
BARATHEON

SELYSE
BARATHEON

RENLY
BARATHEON

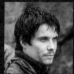 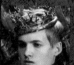

GENDRY

BARATHEON

MYRCELLA
BARATHEON

TOMMEN
BARATHEON

MARGAERY
TYRELL

SHIREEN
BARATHEON

Small Council

KEVAN
LANNISTER

MACE
TYRELL

QYBURN

TRYSTANE
MARTELL

King Tommen's Court

JAIME
LANNISTER

PETYR
"LITTLEFINGER"
BAELISH

ILYN
PAYNE

MERYN
TRANT

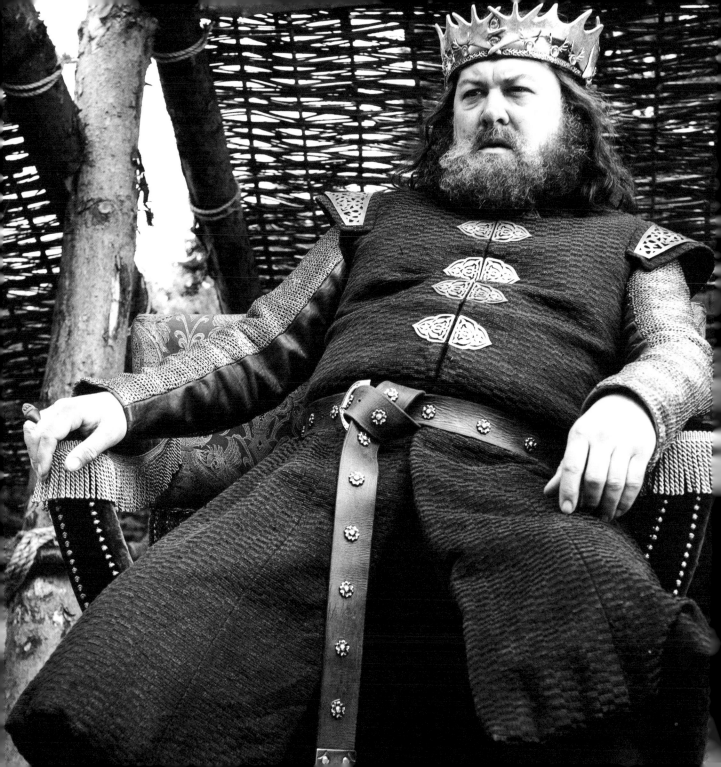

THE FAMILY

ROBERT BARATHEON

After Rhaegar Targaryen kidnapped his fiancée, Lyanna Stark, Robert Baratheon led a rebellion against the Mad King Aerys Targaryen. Aided by his childhood friend, Lyanna's brother, Ned Stark, Robert was subsequently crowned king. When he died suddenly in a hunting accident, his heir Joffrey claimed the throne.

JOFFREY BARATHEON

Over-indulged and cowardly, King Joffrey exhibited a cruel streak toward the vulnerable—a trait for which his uncle Tyrion had little patience. Tyrion now stands accused of murdering Joffrey at his wedding celebration.

MYRCELLA BARATHEON

Cersei's only daughter, Myrcella was sent to Dorne as part of a deal her uncle Tyrion struck with House Martell to align their houses and keep the princess safe. Betrothed to Trystane Martell, son of Prince Doran, she was poisoned by Ellaria Sand, who wished to avenge the death of her lover Oberyn Martell. Myrcella died in the arms of Jaime Lannister, whom she acknowledged as her father before her death.

TOMMEN BARATHEON

The youngest of Cersei's children, Tommen inherited the throne after the death of his brother Joffrey. Now married to his brother's widow, Margaery Tyrell, he was unable to intervene when the High Septon arrested her for perjury.

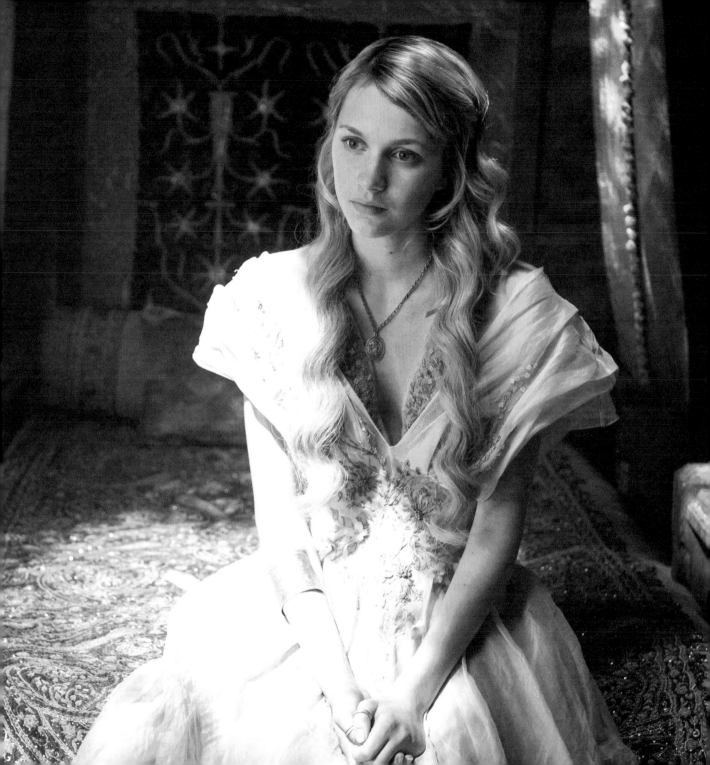

THE SMALL COUNCIL

PYCELLE

Although Pycelle provided counsel and medical attention to the past six kings and served the Lannisters faithfully, he was removed from his position by Cersei Baratheon. Qyburn has since taken over Pycelle's lab.

QYBURN

Qyburn studied to be a maester but wears no chain because the Citadel expelled him for unauthorized experiments. Intrigued by his abilities, Cersei gave him Pycelle's lab and, after Varys' disappearance named him Master of Whisperers. During Cersei's imprisonment, Qyburn became Cersei's only ally—well, almost only.

KING TOMMEN'S COURT

ILYN PAYNE

Ser Ilyn silently carries out the king's orders of execution, and is therefore known as "The King's Justice." Mad King Aerys had Ilyn's tongue torn out when he heard a rumor that Ser Ilyn had claimed Tywin Lannister held more power than the king. At King Joffrey's command, Ilyn executed Ned Stark.

MERYN TRANT

One of Joffrey's most loyal Kingsguards, Ser Meryn took care of much of Joffrey's dirty work. His devotion to the late king put him at odds with Tyrion Lannister, and he was the first to testify against Tyrion when he stood trial for Joffrey's murder. Meryn Trant was killed in Braavos by Arya Stark, who held him responsible for the death of her teacher, Syrio Forel.

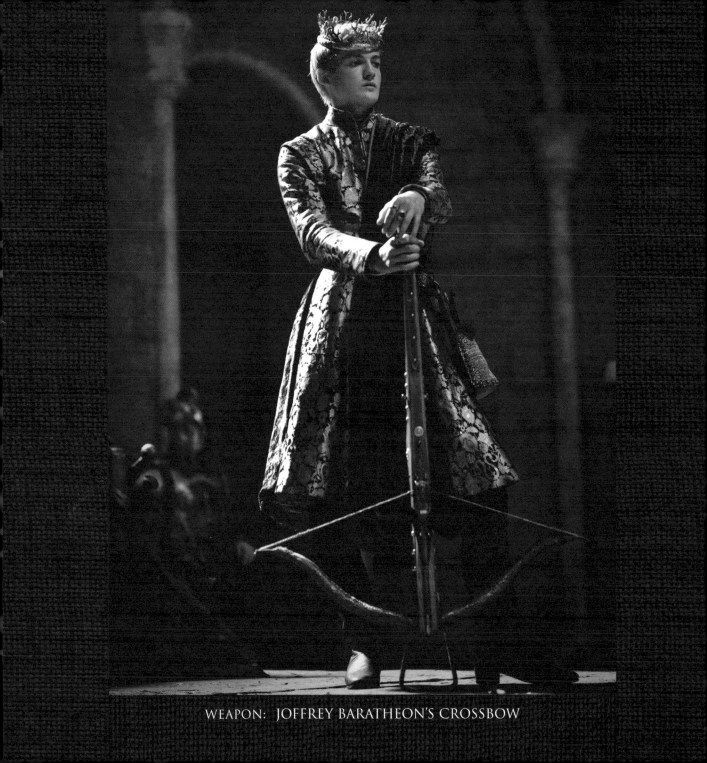

WEAPON: JOFFREY BARATHEON'S CROSSBOW

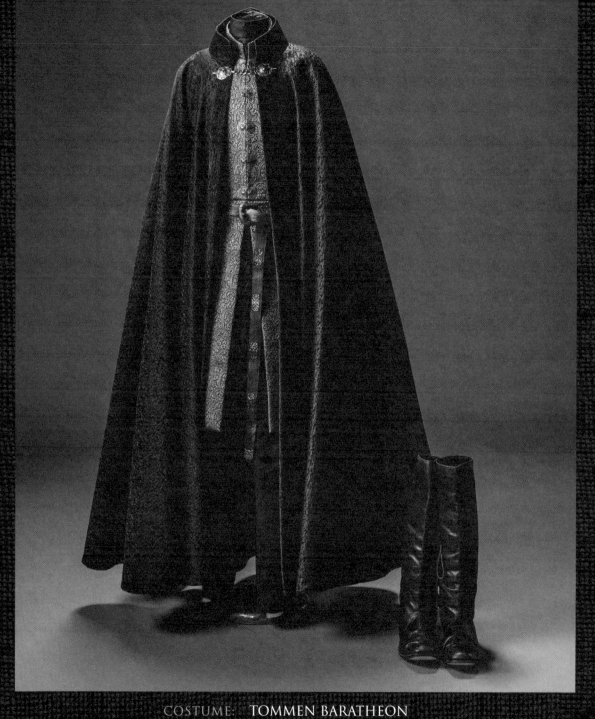

COSTUME: **TOMMEN BARATHEON**

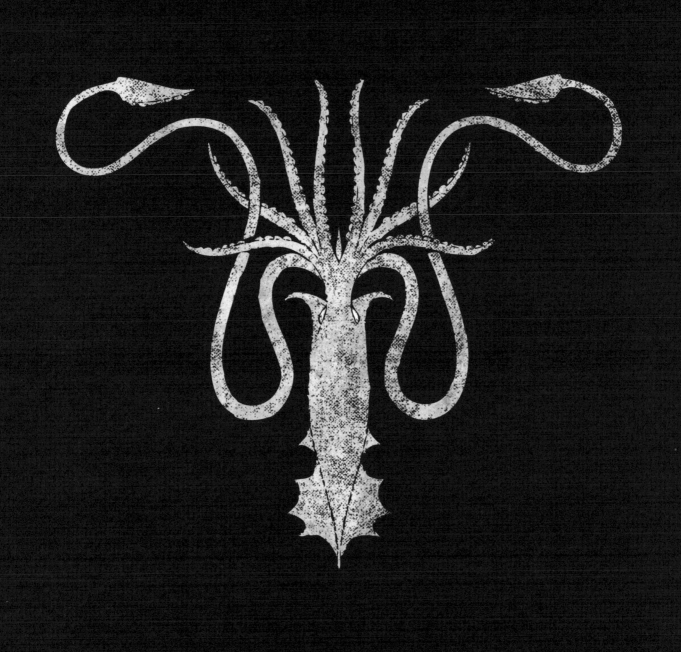

HOUSE GREYJOY

WE
DO NOT
SOW

SEAT: PYKE REGION: THE IRON ISLANDS

The ancient stronghold, which takes its name from the island it stands on, is situated on a scattering of huge stones in the sea, with bridges connecting its towers. Its rocky, moss-covered foundations prevent any ships from landing.

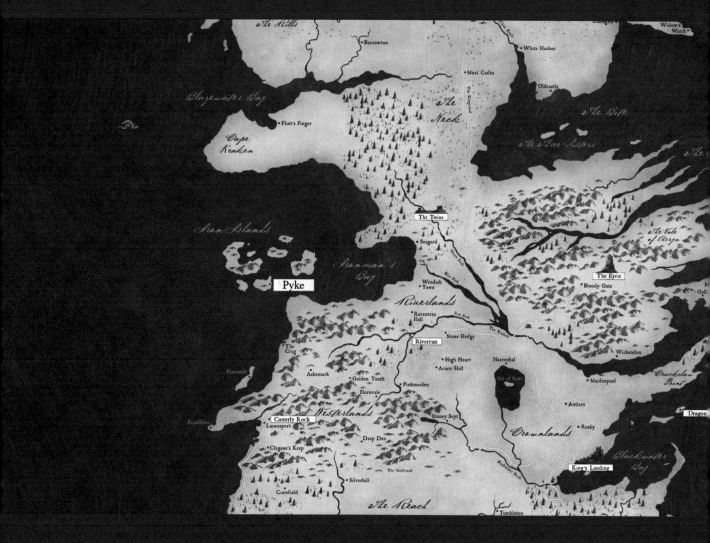

History

House Greyjoy's power dates back to the reign of the great Grey King during the Age of Heroes. Legend has it that the Grey King ruled the sea itself and took a mermaid for his wife. While still the ruling family of the Iron Islands, the Greyjoys have always had larger designs.

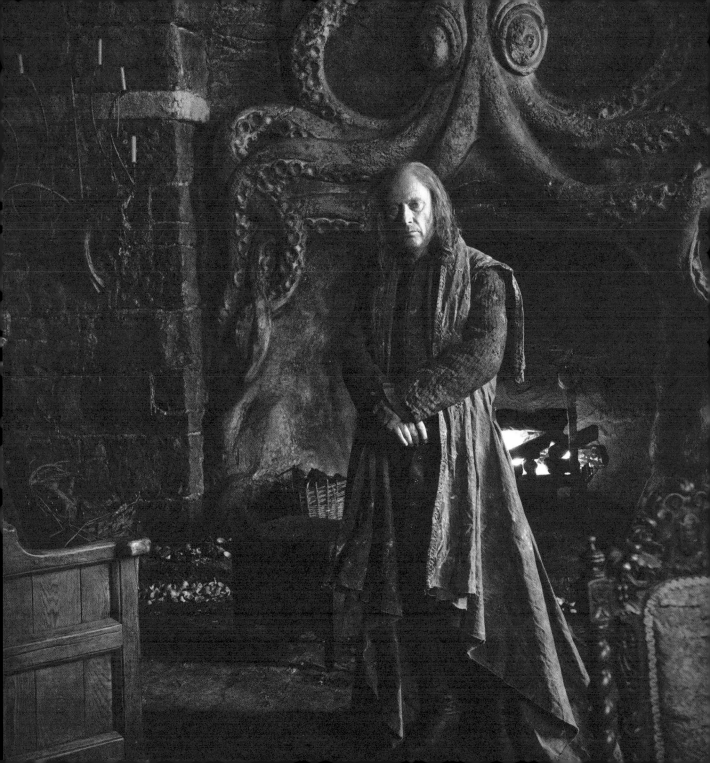

FAMILY TREE

BALON
GREYJOY

ALANNYS
GREYJOY

RODRIK
GREYJOY

MARON
GREJOY

YARA
GREYJOY

THEON
GREYJOY

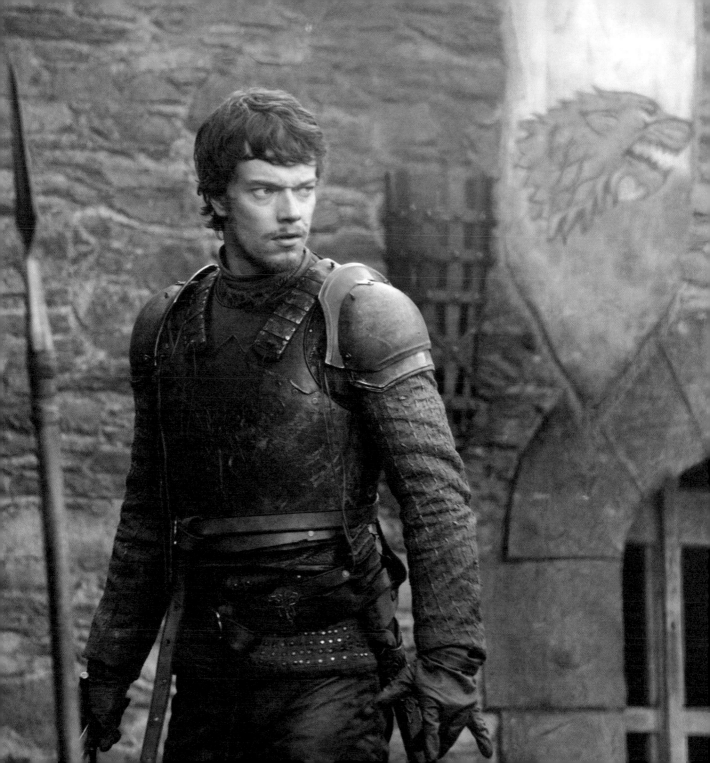

THE FAMILY

BALON GREYJOY

Head of the ruling house of the Iron Islands, Balon Greyjoy revolted against Robert Baratheon in an attempt to win the Islands their independence. Two of his sons died in the battle and Balon was forced to surrender his only surviving son, Theon, to Ned Stark to raise as a ward. Upon Theon's return to the Iron Islands many years later, Balon encouraged his son to renounce his ties to the Starks and help him vanquish the North. The plot failed when Ramsay Snow took Theon prisoner and emasculated him. While aware that Theon is still alive, Balon no longer considers him his son.

YARA GREYJOY

Theon's older sister, Yara, is the only child of Balon Greyjoy who remains on the Iron Islands. Initially committed to her brother's safe return, Yara abandoned Theon after a failed rescue attempt at the Dreadfort.

THEON GREYJOY

Formerly a ward of House Stark and prince of the Iron Islands, Theon was quick to support his friend Robb's rebellion against King Joffrey. But upon returning to his ancestral home on Pyke as Robb's envoy, Theon joined his father's forces and betrayed the family that raised him. Theon seized Winterfell, but was taken prisoner by Ramsay Snow, who tortured him into renouncing his identity. Although he lives in terror of his master Ramsay, Theon joined Sansa Stark in an attempt to escape from the castle, leaping from its walls.

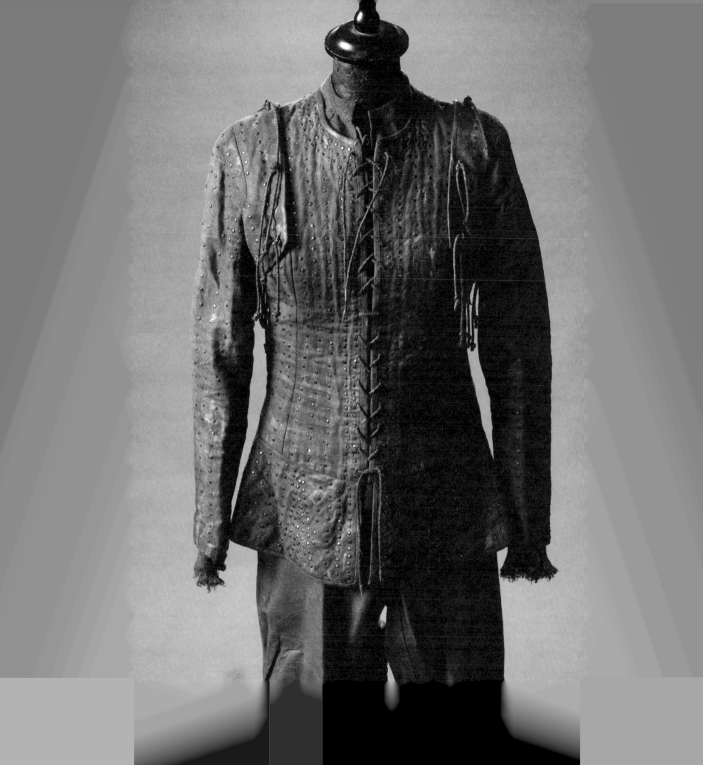

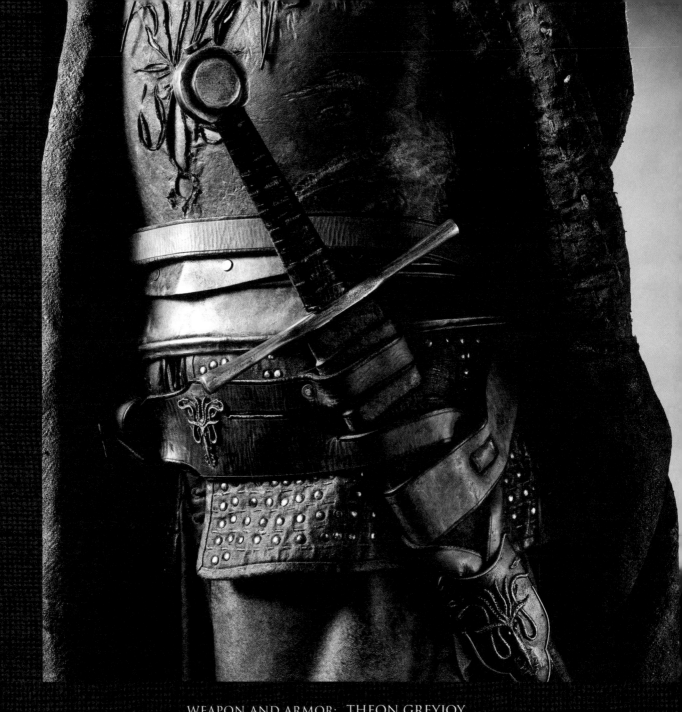

WEAPON AND ARMOR: THEON GREYJOY

HOUSE TYRELL

Growing Strong

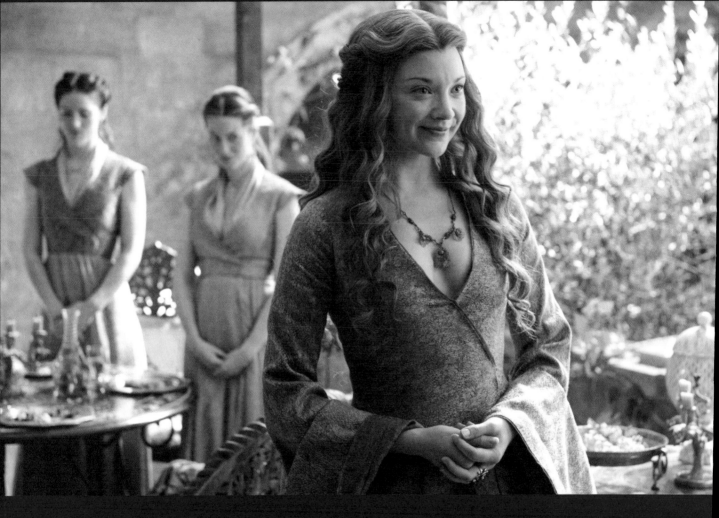

Once the seat of House Gardener, this keep fell into the hands of its steward—Harlen Tyrell—when he surrendered to the conqueror Aegon Targaryen. The Tyrells have served as principal house in the region ever since.

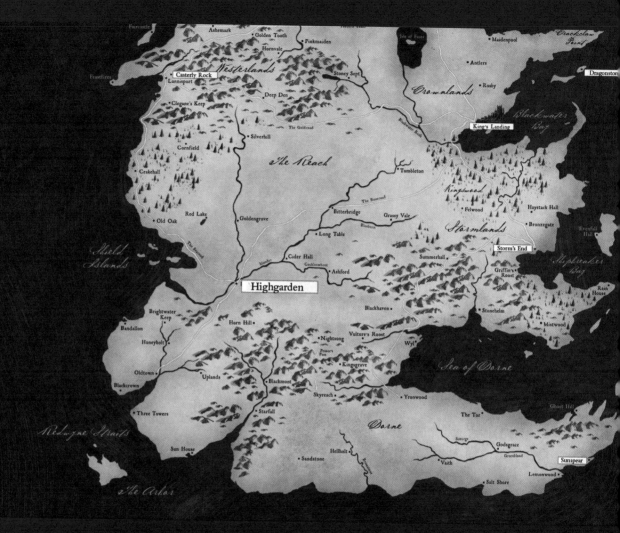

History

For centuries, the Tyrells served and occasionally intermarried with House Gardener, the ancient family of the King of the Reach. But after the Targaryen conquest eliminated the Gardeners, the Tyrells bent the knee to the Iron Throne—and then rose to become principal house and warden of the South. They've since thrown their support with the Lannisters.

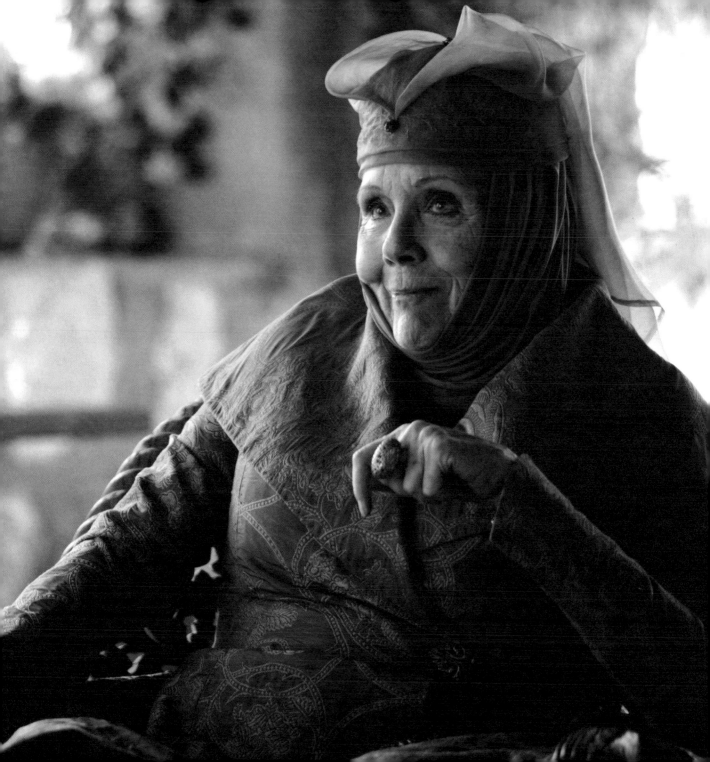

Family Tree

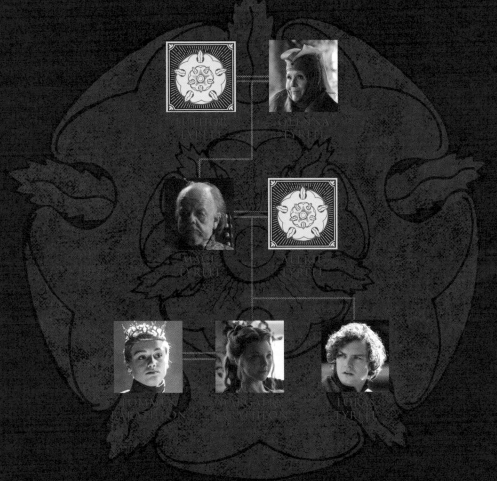

LUTHOR
TYRELL

OLENNA
TYRELL

MACE
TYRELL

ALERIE
TYRELL

LORAS
TYRELL

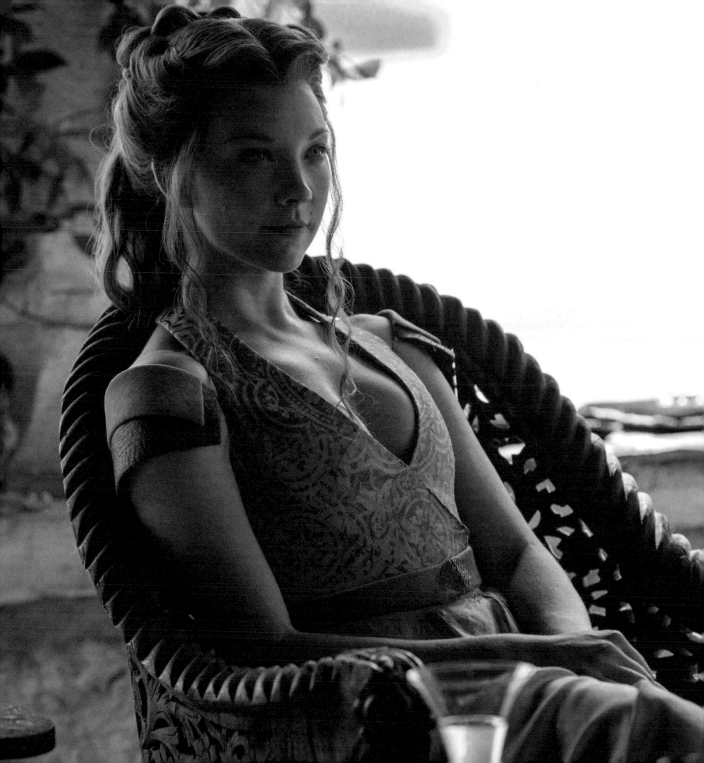

THE FAMILY

OLENNA TYRELL

Matriarch of House Tyrell, Lady Olenna is not shy about sharing her opinions. She is fond of her granddaughter Margaery, but less generous toward the men in her family. Lady Olenna returned to King's Landing after the arrest of her grandson Loras, but discovered the High Sparrow to be incorruptible.

MACE TYRELL

Lord of Highgarden, Warden of the South, and father to Margaery Tyrell, Mace Tyrell serves as Master of Ships on the Small Council. When Cersei took charge of the Council, she added Master of Coin to his responsibilities and sent Mace to Braavos to renegotiate the kingdom's terms with the Iron Bank.

MARGAERY BARATHEON

Mace Tyrell's only daughter, Margaery, is as clever as she is beautiful. Widowed by both Renly Baratheon and King Joffrey, she married Joffrey's brother, Tommen in an effort to maintain an alliance between the Tyrells and the Lannisters. She was taken into custody for bearing false witness before the gods when she lied to defend her brother Loras against accusations of perversion.

LORAS TYRELL

The handsome young Ser Loras was the secret lover of Renly Baratheon, for whom he served as Kingsguard. After Renly's murder, Loras unknowingly took a spy for Littlefinger, Olyvar, as his lover, though Loras was obligated to marry Cersei Lannister. Cersei engineered her fiancé's arrest by the Faith Militant to undermine the Tyrells' influence in King's Landing. Margaery's participation in her brother's defense landed her in prison for bearing false witness before the gods.

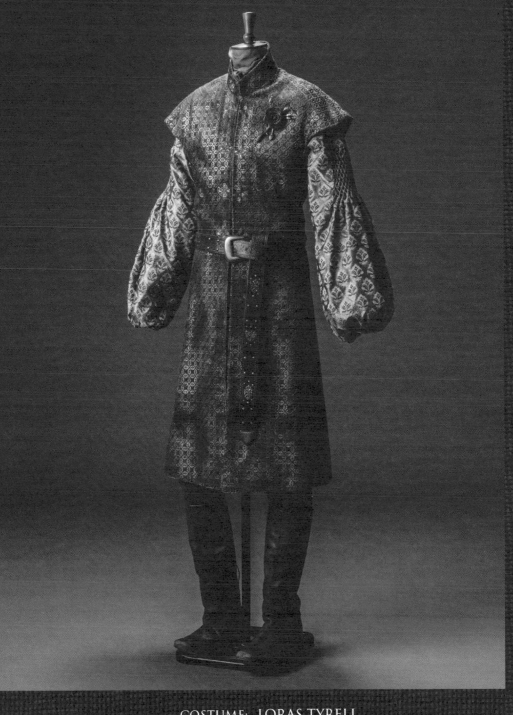

COSTUME: LORAS TYRELL

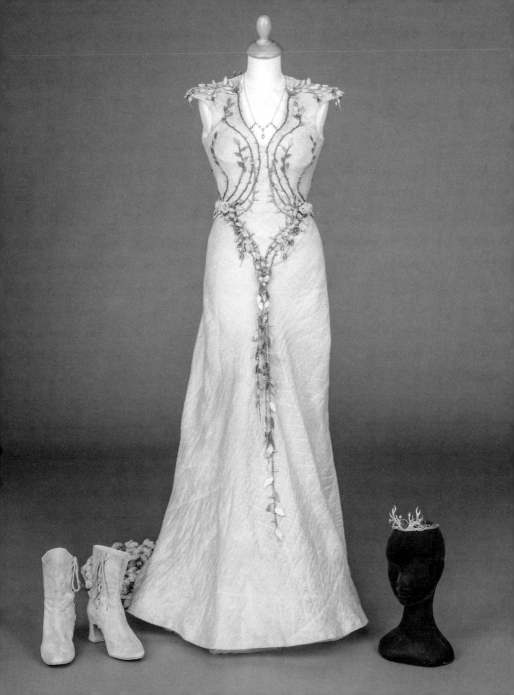

HOUSE
FREY

SEAT: **THE TWINS** REGION: **THE RIVERLANDS**

The Frey family spent three generations building their river-spanning fortress, and they've grown rich from the tolls charged to travelers for crossing.

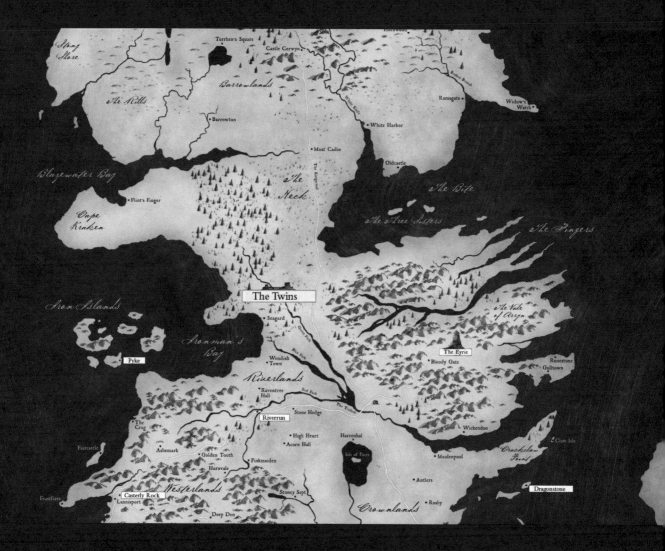

The Twins

HISTORY

The Freys served as bannermen to House Tully for generations, shoring up their wealth by charging travelers a fee to cross over the Trident River via their castle, the Twins. Ever ambitious, the family tends to marry up, a tradition encouraged by the current Lord of the Crossing, Walder Frey. After ambushing the Stark troops at the wedding of his daughter Roslin, Walder Frey also assumed the title of Lord Paramount of the Riverlands.

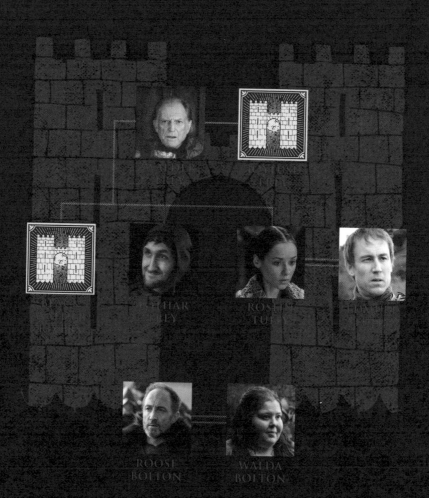

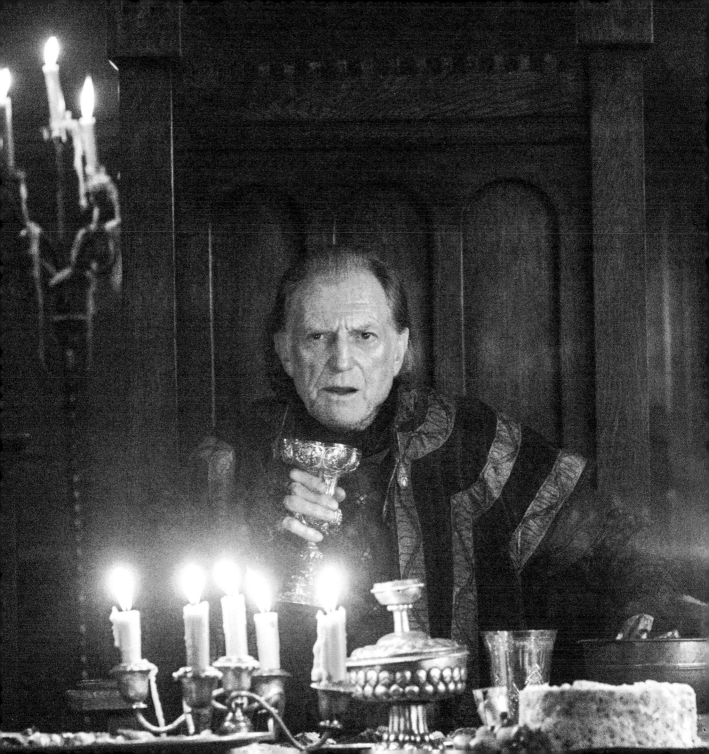

THE FAMILY

WALDER FREY

Lord Walder Frey is patriarch to a brood of more than 100 descendants, a result of his many marriages. An attempt to increase his family's stature by engaging one of his girls to Robb Stark failed when Rob broke his promise. Unsatisfied with King Robb's attempts to make amends, Lord Walder wreaked his vengeance by massacring his Stark guests at the wedding of Edmure Tully to his daughter Roslin.

JOYEUSE FREY

Only fifteen when she married her ninety-year-old-husband, Joyeuse is just one in a long line of wives for Walder Frey. She was present at the Red Wedding, where Catelyn Stark took her captive and pleaded with Lord Walder to trade her for Catelyn's son Robb. When Walder refused to make the exchange Catelyn killed Joyeuse.

BLACK WALDER RIVERS

A bastard son of Walder Frey, Black Walder is so known because of his dark temper. He accompanied his brother Lothar to Riverrun where they met with Robb Stark to negotiate the marriage of Edmure Tully to their sister Roslin. On the night of the wedding, Black Walder slit Catelyn Stark's throat.

THE FAMILY

LOTHAR FREY

One of Walder Frey's many sons, Lothar accompanied his brother Black Walder to Riverrun where they met with Robb Stark to negotiate the marriage of Edmure Tully to their sister Roslin. On the night of the wedding, Lothar stabbed Robb's wife, Talisa, in the abdomen, thus initiating the massacre of the Red Wedding.

ROSLIN TULLY

The fairest of the Frey girls and newly wed to Edmure Tully, Roslin was married off as part of a bargain her father made with Robb Stark. Her wedding night erupted into a violent battle that obliterated the Stark army and became known as the Red Wedding.

WALDA BOLTON

Roose Bolton's new bride, Walda is a granddaughter of Lord Walder Frey. Bolton specifically chose the heavy-set young woman because Lord Walder promised him a dowry equivalent to his wife's weight in silver. She and Roose are now expecting a child.

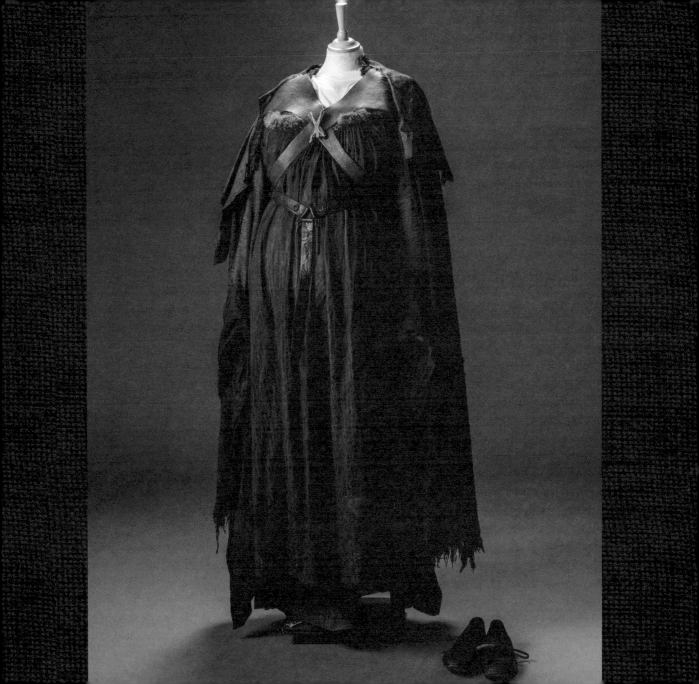

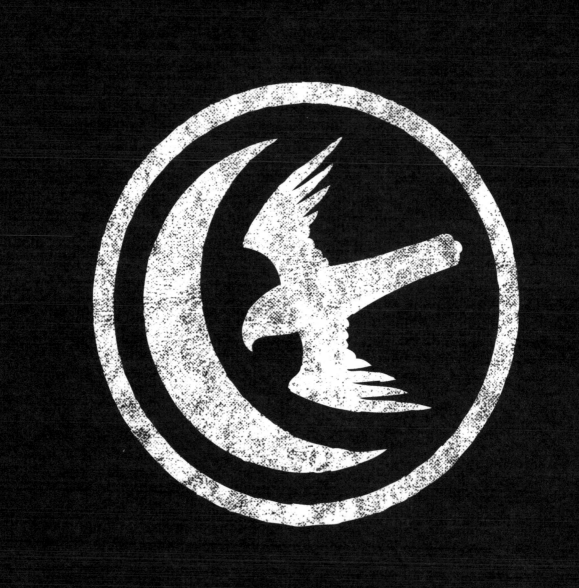

HOUSE ARRYN

As High
As Honor

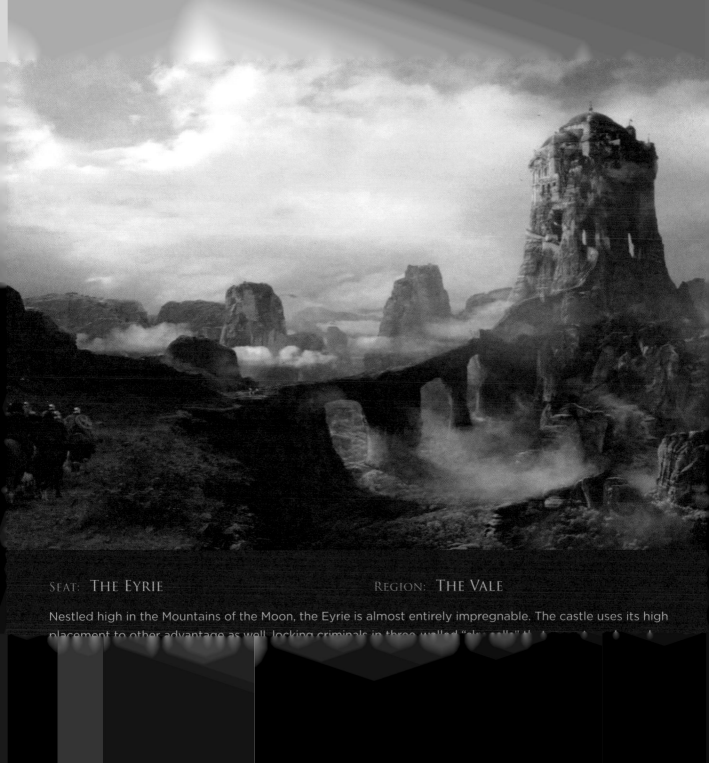

SEAT: THE EYRIE **REGION:** THE VALE

Nestled high in the Mountains of the Moon, the Eyrie is almost entirely impregnable. The castle uses its high placement to other advantage as well, locking criminals in three-walled "sky cells"

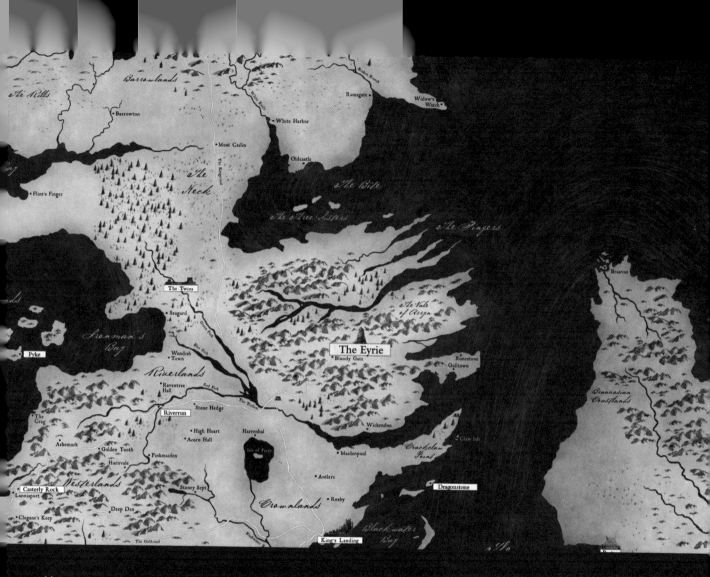

The Eyrie

HISTORY

Located in the Vale, the Arryns serve as Warden of the East from their mountain stronghold, the Eyrie—a key defense against the violent clans that surround their home. The widowed Lysa Arryn retired here, keeping

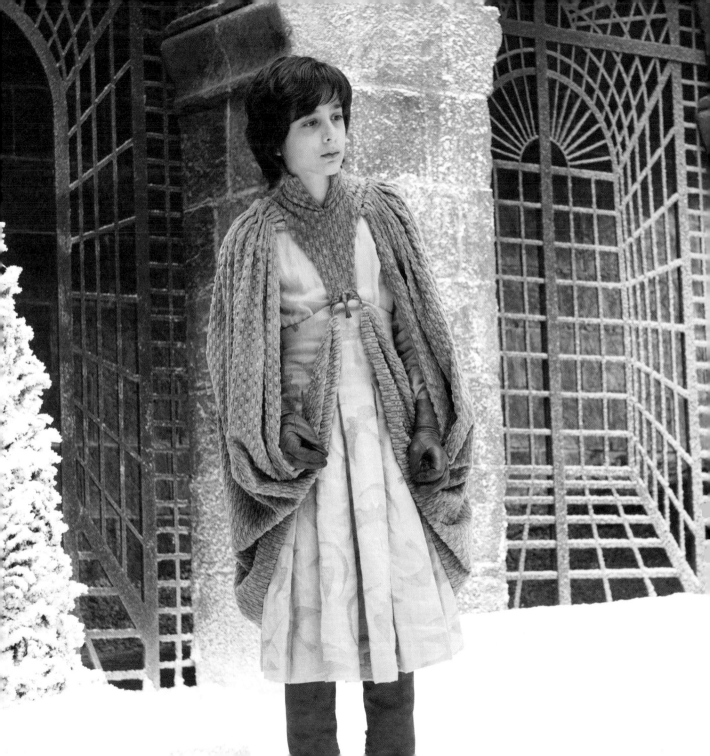

Family Tree

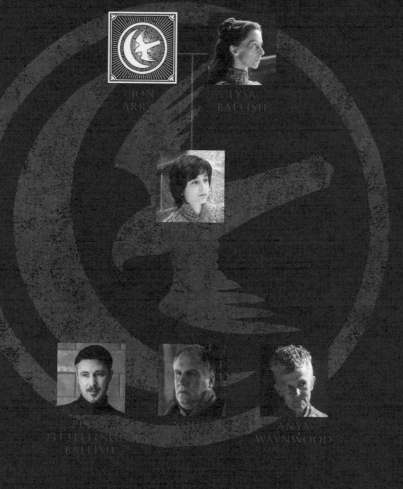

JON
ARRYN

LYSA
BAELISH

ROBIN
ARRYN

PETYR
LITTLEFINGER
BAELISH

YOHN
ROYCE

ANYA
WAYNWOOD

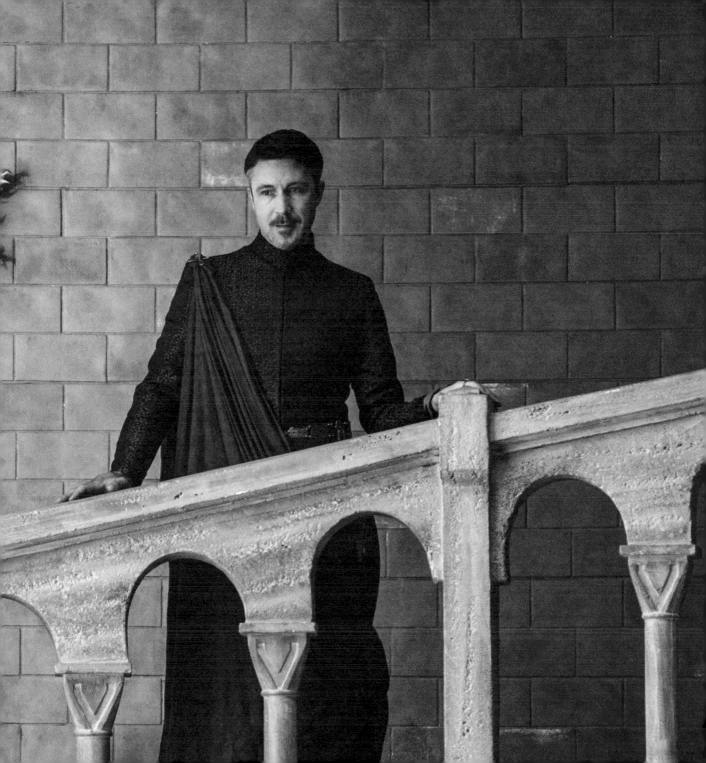

THE FAMILY

JON ARRYN

Foster father of both Robert Baratheon and Ned Stark, Jon Arryn served as Robert's Hand of the King until his untimely death. He was married to Lysa Tully, the younger sister of Catelyn Stark, a marriage that bound his family with Ned's during a time of war.

LYSA BAELISH

Catelyn Stark's younger sister, Lysa was married off to the much older Jon Arryn (the former Hand of the King) when Robert Baratheon led his rebellion against the Mad King Aerys. After her husband's unexpected death, Lysa fled to the Eyrie, where she kept a careful eye on her son Robin and avoided the war below. She eagerly married her childhood love, Petyr Baelish—who courted her to secure the region for the kingdom— but he killed her when she threatened her niece Sansa.

ROBIN ARRYN

Robin Arryn lived an extremely sheltered life in the Eyrie under his mother's watchful eye. Now orphaned, Robin was left behind at Runestone to foster with Lord Royce while Littlefinger travels with Sansa.

PETYR "LITTLEFINGER" BAELISH

Littlefinger was a childhood friend of the Tully sisters, Lysa and Catelyn, the latter of whom he loved deeply. Littlefinger married Lysa Arryn to secure the Vale to the Lannister's side but he always had his eye on Sansa Stark. He arranged for her escape to the Eyrie after Joffrey's murder and he killed his new bride when she threatened Sansa. Sansa then protected Littlefinger by claiming her aunt took her own life. Littlefinger has engaged Sansa to marry Ramsay Bolton . . . but has also offered Cersei the Knights of the Vale to take the North.

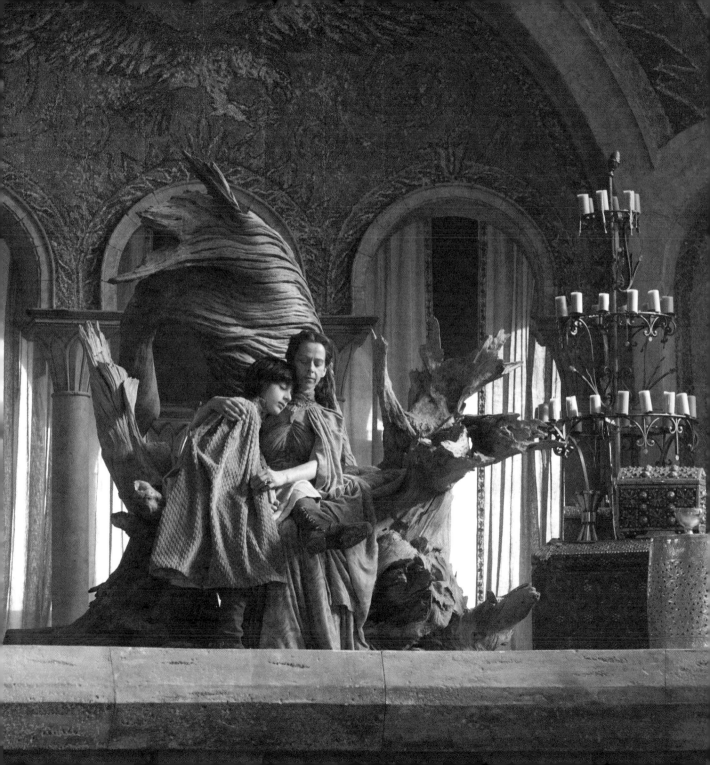

SWORN TO HOUSE ARRYN

YOHN ROYCE

A lord of the Vale, Ser Yohn met Sansa Stark at Winterfell when he escorted his son Waymar to join the Night's Watch. Although initially distrustful of Littlefinger's motives, he was swayed by Sansa's testimony on Lord Baelish's behalf.

ANYA WAYNWOOD

A highborn lady of the Vale, Lady Anya was present when Sansa Stark explained the circumstances surrounding the death of her aunt Lysa, and provided comfort to the grieving girl.

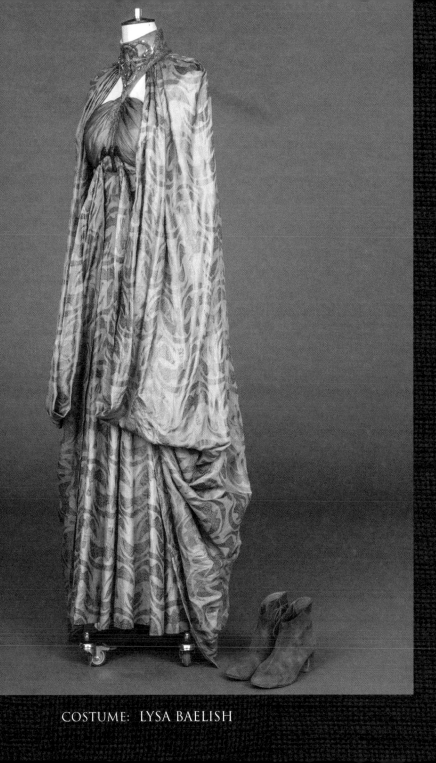

COSTUME: LYSA BAELISH

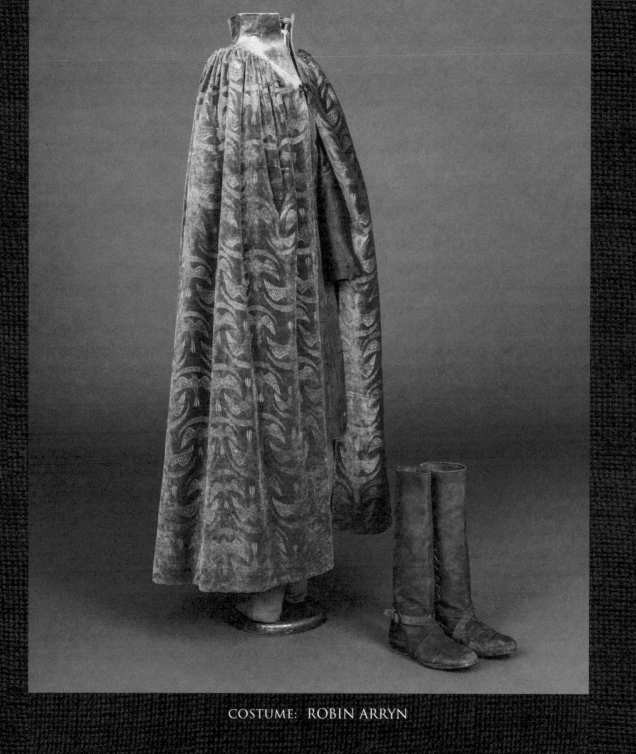

COSTUME: ROBIN ARRYN

HOUSE TULLY

FAMILY
DUTY
HONOR

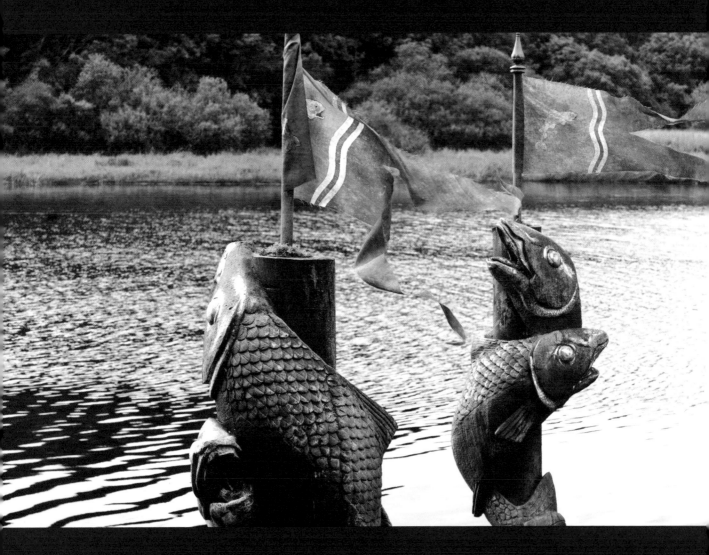

SEAT: RIVERRUN **REGION: THE RIVERLANDS**

The lush Riverlands lack the natural defenses of some other regions, but the seat of Riverrun itself has a unique barricade. The three-sided castle on the Red Fork of the Trident River can redirect the water's flow to completely encompass its walls, blocking attack. After the Red Wedding, Tywin Lannister awarded Riverrun, the long-time seat of House Tully, to Lord Walder Frey for his service to the crown.

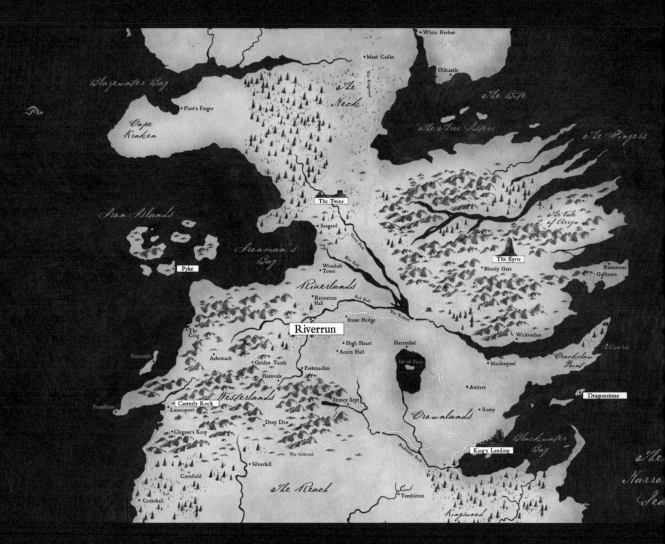

Blazewater Bay

Flint's Finger

Cape Kraken

Iron Islands

Pyke

Ironman's Bay

The Neck

White Harbor

Moat Cailin

Oldcastle

The Bite

The Three Sisters

The Fingers

The Twins

Seagard

Wendish Town

Riverlands

Raventree Hall

Green Fork

Blue Fork

Red Fork

The Trident

Bloody Gate

The Eyrie

The Vale of Arryn

Runestone

Gulltown

Riverrun

The Crag

Ashemark

Golden Tooth

Hornvale

Fairastle

Stone Hedge

High Heart

Acorn Hall

Pinkmaiden

Harrenhal

Isle of Faces

Wickendon

Claw Isle

Crackclaw Point

Maidenpool

Feastfires

Casterly Rock

Lannisport

Westerlands

Deep Den

Clegane's Keep

Stoney Sept

Antlers

Rosby

Crownlands

Dragonstone

The Goldroad

Silverhill

Cornfield

Crakehall

The Reach

Tumbleton

Blackwater Rush

King's Landing

Blackwater Bay

The Narrow Sea

Kingswood

HISTORY

Once the principal house of the Riverlands, the Tullys rose to power during the Targaryen conquest. Along with House Stark, the family was betrayed by Walder Frey at the Red Wedding, a massacre that left the Riverlands and Riverrun, the Tully family seat, under Frey control.

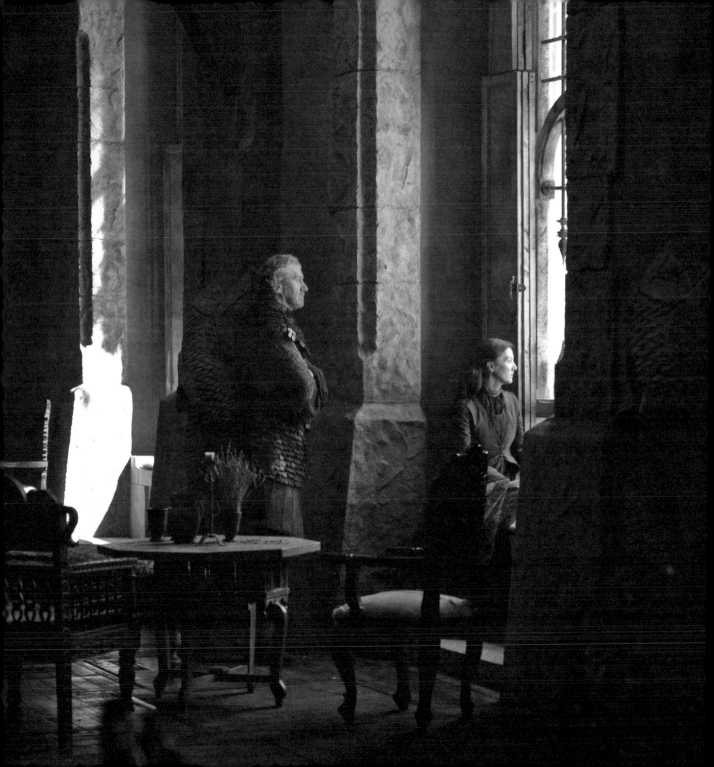

FAMILY TREE

MINISA
TULLY

HOSTER
TULLY

BRYNDEN
"THE BLACKFISH"
TULLY

EDDARD
"NED" STARK

CATELYN
STARK

JON
ARRYN

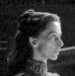
LYSA
BAELISH

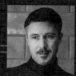
PETYR
"LITTLEFINGER"
BAELISH

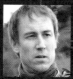
EDMURE
TULLY

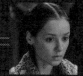
ROSLIN
TULLY

ROBIN
ARRYN

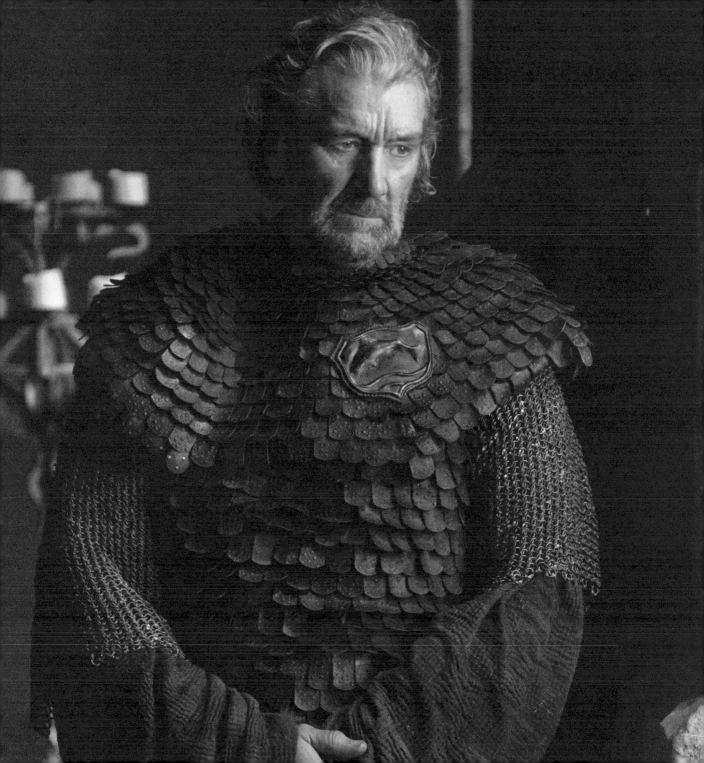

THE FAMILY

HOSTER TULLY

Lord of Riverrun and Lord Paramount of the Riverlands, Lord Hoster passed away during the war. He was especially close to his daughter Catelyn, who would watch from the castle's windows awaiting his return whenever he traveled. A skilled strategist in his heyday, he arranged for his daughters, Catelyn and Lysa to marry Ned Stark and Jon Arryn during Robert's Rebellion, thus solidifying his family's power when Robert Baratheon took the throne.

BRYNDEN "THE BLACKFISH" TULLY

Brynden is known as "The Blackfish" due to the strained relationship he had with his older brother Hoster. Alongside Barristan Selmy, Brynden showed great heroism during the War of the Ninepenny Kings, a rebellion in the East that threatened the Seven Kingdoms. Though he was present at the Twins for his nephew Edmure's wedding to Roslin Frey, the Blackfish managed to escape before the carnage began.

EDMURE TULLY

Younger brother to Catelyn Stark and Lysa Arryn, Edmure fought on Robb Stark's behalf throughout the Riverlands. Although well-intentioned, he lacks the military instincts of his father and uncle. As part of a bargain made with Walder Frey, Edmure married Walder's daughter Roslin; the violence that ensued that day obliterated the Stark army and became known as the Red Wedding. Unharmed, Edmure is now being held hostage by his in-laws.

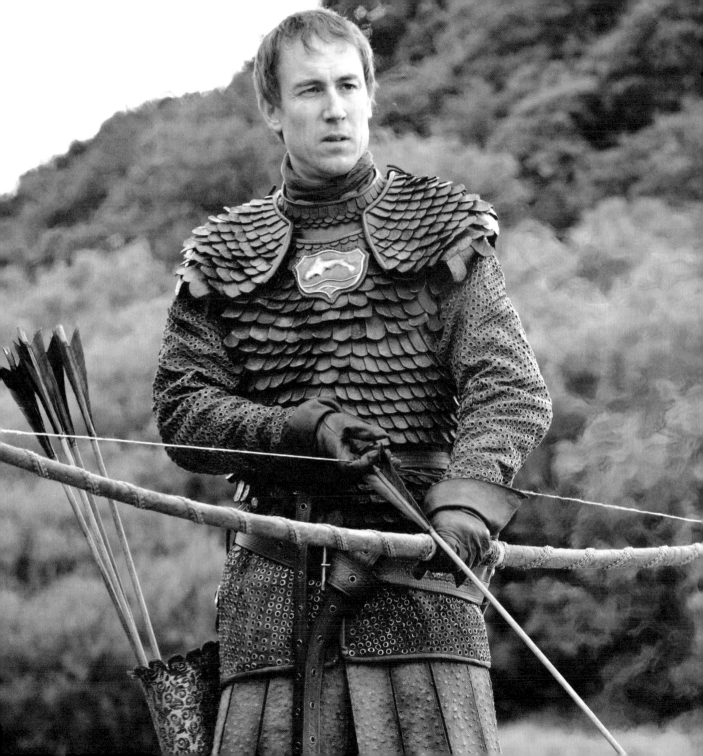

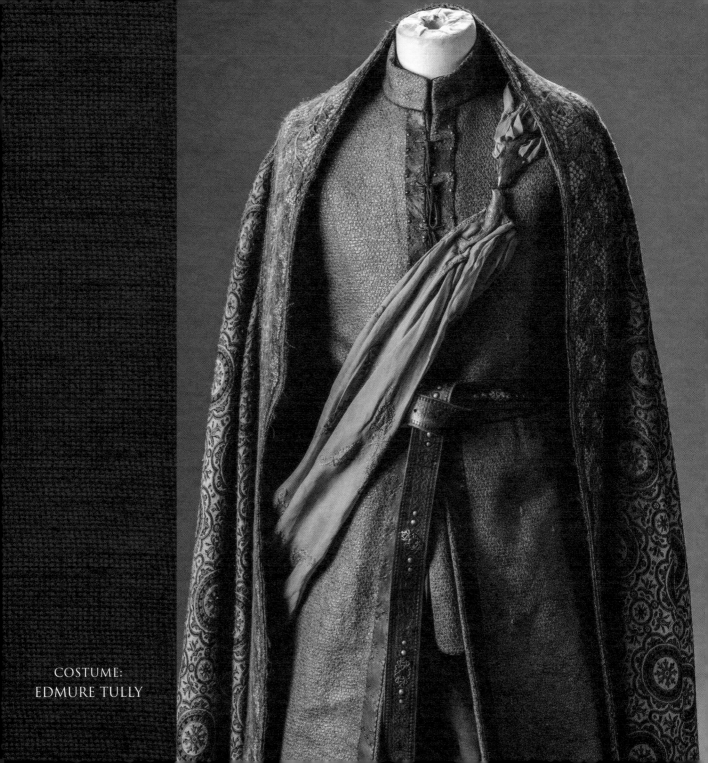

COSTUME:
EDMURE TULLY

HOUSE BOLTON

Our Blades are Sharp

Seat: Winterfell, formerly The Dreadfort **Region:** The North

A powerful house in the North, the Boltons have been known to skin their enemies alive. It is rumored that the skins of several ancient Starks still hang in the dungeons of the Dreadfort.

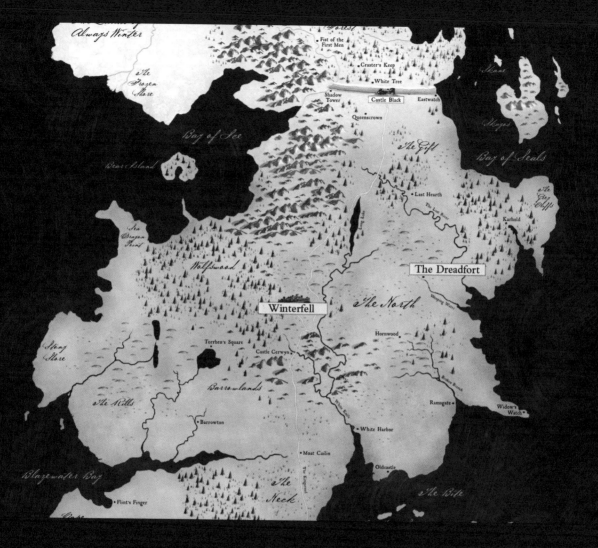

Always Winter

The Frozen Shore

Forest

Fist of the First Men

Craster's Keep

White Tree

Shadow Tower

Castle Black

Eastwatch

Skane

Skagos

Queenscrown

Bay of Ice

The Gift

Bay of Seals

Bear Island

Last Hearth

The Grey Cliffs

The Long Lake

The Last River

Karhold

Sea Dragon Point

Wolfswood

The Dreadfort

Winterfell

The North

Weeping Water

Hornwood

Torrhen's Square

Castle Cerwyn

Stony Shore

The Rills

Barrowlands

Broken Branch

Ramsgate

Widow's Watch

Barrowton

White Knife

White Harbor

Blazewater Bay

Moat Cailin

Oldcastle

The Bite

Flint's Finger

The Neck

The Kingsroad

History

Although the practice of flaying has been outlawed in the North, the Boltons still believe in its effectiveness; flayed skins of their fallen enemies hang in the Dreadfort. For generations, the Boltons served as bannermen to House Stark, their ancient rivals. This alliance came to an end at the Red Wedding, when Roose Bolton killed Robb Stark, an act of treachery that earned him Winterfell and the title of Warden of the North.

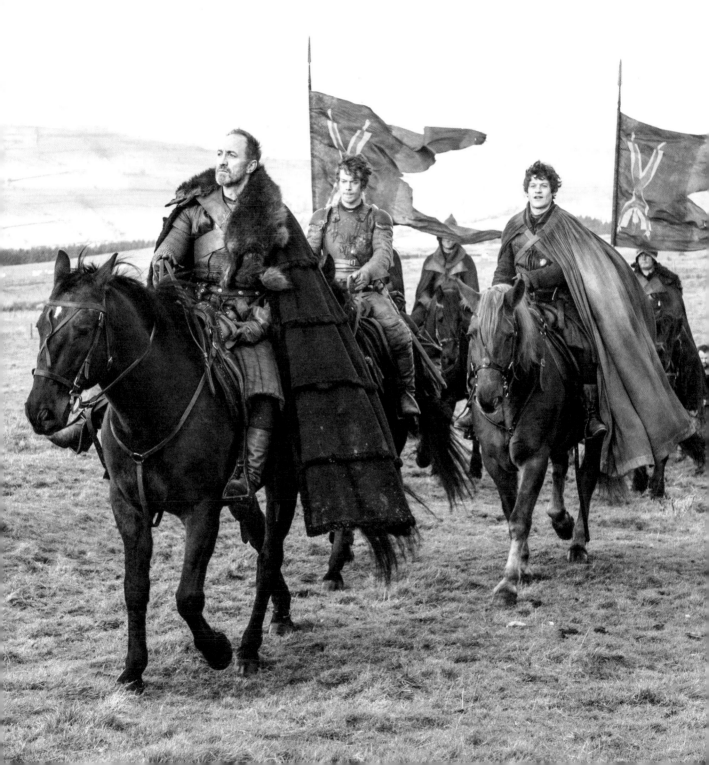

FAMILY TREE

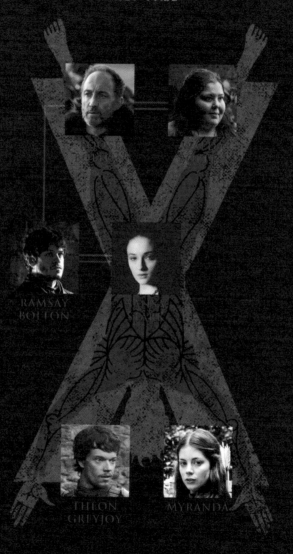

RAMSAY
BOLTON

THEON
GREYJOY MYRANDA

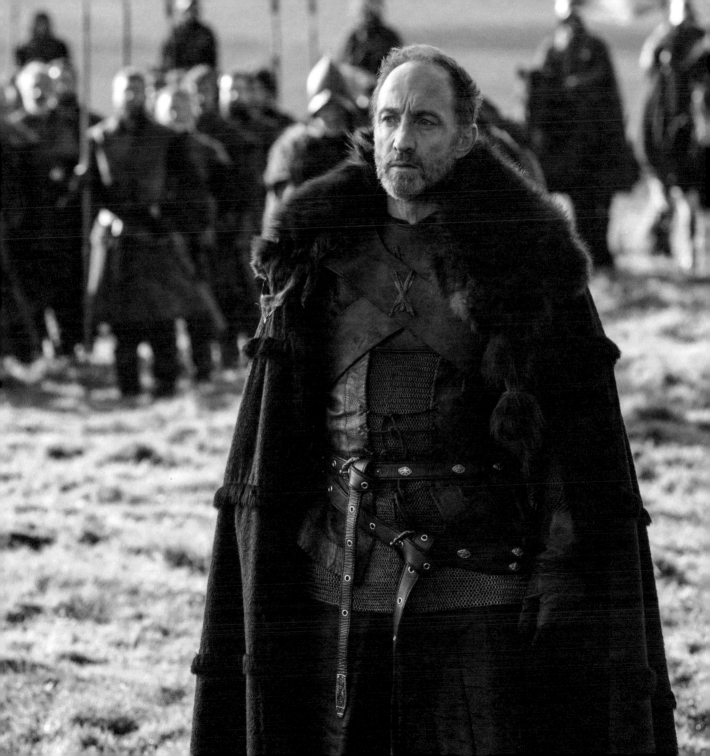

THE FAMILY

ROOSE BOLTON

Lord of the Dreadfort and head of House Bolton, Roose takes pride in his family name and ruthlessly seeks its advancement. A proven soldier who fought at the Battle of the Trident, Bolton joined arms with Robb Stark only to betray him at the Red Wedding to gain favor with Tywin Lannister. He broke that alliance when, with Littlefinger he arranged for his newly-legitimate son Ramsay to marry Sansa Stark to solidify his position as Warden of the North. Roose is expecting a child with his new wife, Walda Frey.

RAMSAY BOLTON

A bastard son of Roose Bolton, the newly legitimized Ramsay captured Theon Greyjoy and tortured him until Theon was a shell of his former self, who Ramsay then renamed "Reek." Ramsay married Sansa Stark and forced Theon to bear witness to their wedding night.

HOUSEHOLD

MYRANDA

Lover to Ramsay Bolton, Myranda has always stood beside Ramsay in all his pursuits. She is jealous of Sansa's new role in Ramsay's life.

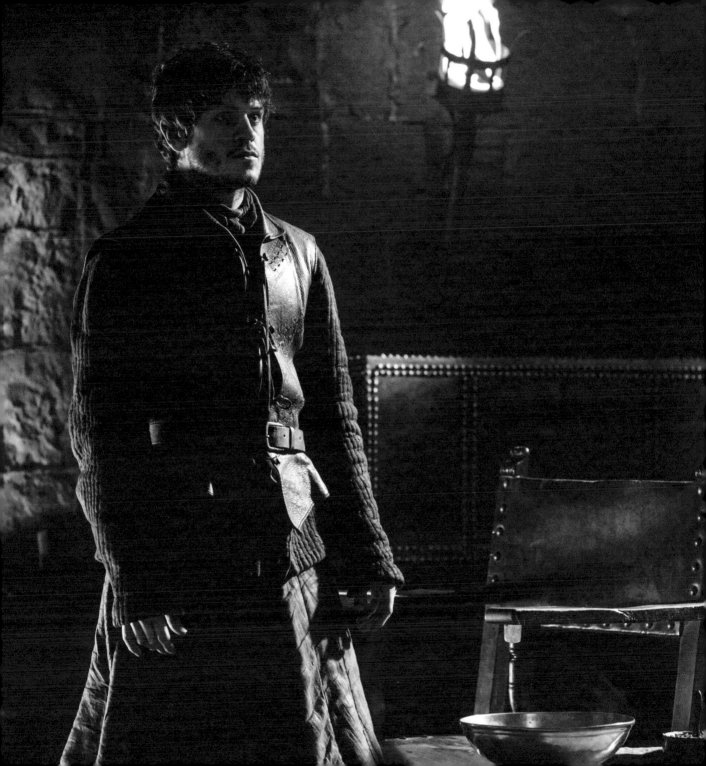

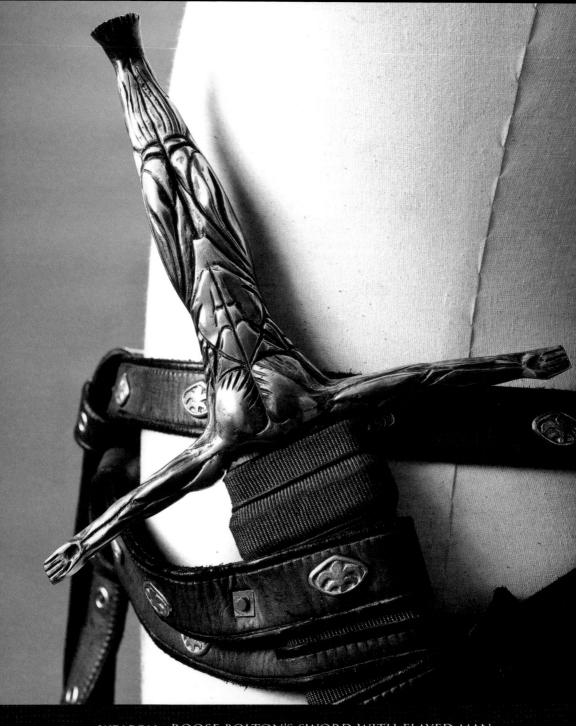

WEAPON: ROOSE BOLTON'S SWORD WITH FLAYED MAN

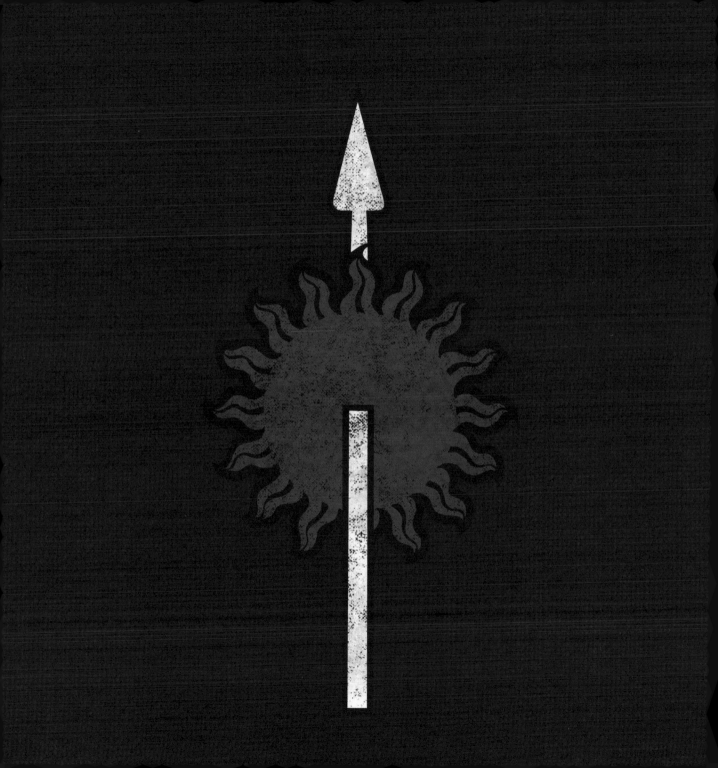

HOUSE MARTELL

UNBOWED

UNBENT

UNBROKEN

Built largely of mud and straw, this southern city serves as the capital of Dorne. It is dominated primarily by the Spear Tower, a 150-foot structure with a pinnacle of shining steel.

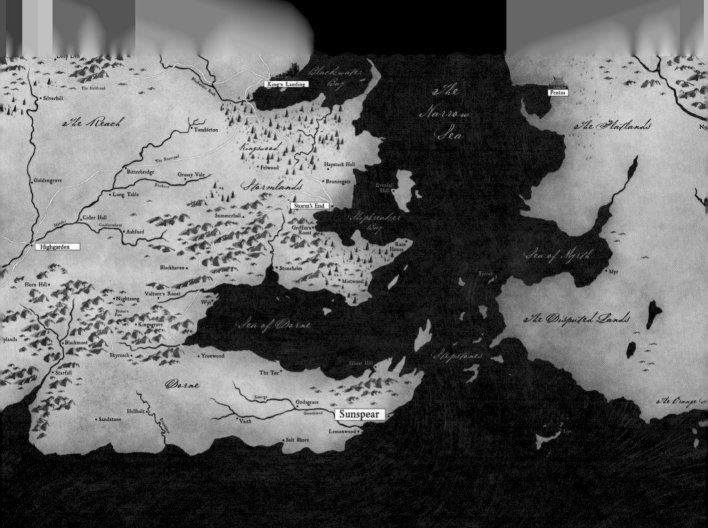

History

In the period of Aegon's Conquest, Dorne resisted all of the Targaryen king's efforts to annex it into the Seven Kingdoms. A marriage alliance between a Targaryen king and a princess of Dorne finally brought the region under the rule of the Iron Throne. The death of Oberyn Martell in King's Landing has complicated the royal family's relationship with the Martells, who were fostering Princess Myrcella

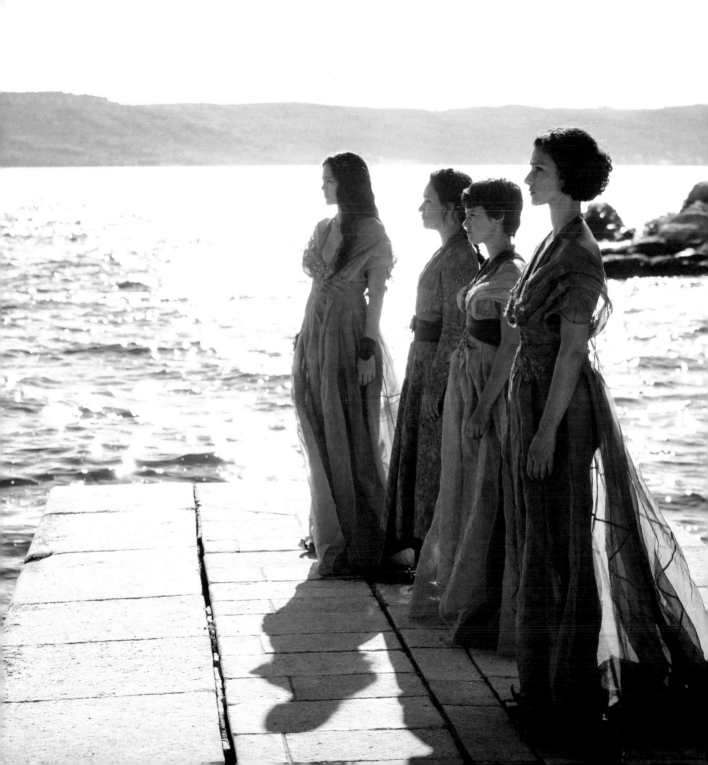

FAMILY TREE

DORAN
MARTELL

ELIA
MARTELL

RHAEGAR
TARGARYEN

OBERYN
MARTELL

ELLARIA
SAND

TRYSTANE
MARTELL

MYRCELLA
BARATHEON

RHAENYS
TARGARYEN

AEGON
TARGARYEN

OBARA
SAND

NYMERIA
SAND

TYENE
SAND

HOUSEHOLD

AREO
HOTAH

THE FAMILY

DORAN MARTELL

Doran Martell, the governing prince of Dorne, suffers from gout and is confined to his wheelchair. A firm and diplomatic leader, Doran stayed largely neutral in the War of the Five Kings. He has continued that stance, even after the death of his younger brother, Oberyn, in King's Landing, refusing to support Ellaria Sand's demand for vengeance. His son, Trystane was engaged to Myrcella Baratheon.

ELIA TARGARYEN

Elia was a Dornish princess and the wife of Rhaegar Targaryen. When Robert Baratheon led his rebellion for the Iron Throne, King Aerys kept Elia in King's Landing to ensure her family's commitment to the Targaryen side. After Robert's triumph, Elia was raped and killed by Gregor "The Mountain" Clegane; her children were murdered as well. Her brother, Oberyn Martell, lost his life seeking vengeance against the Mountain.

RHAEGAR TARGARYEN

The heir to the Targaryen throne, Rhaegar began the feud between the Starks and the Targaryens by riding off with Ned Stark's sister Lyanna. Robert Baratheon, affianced to Lyanna, slew Rhaegar in hand-to-hand combat at the Battle of the Trident.

OBERYN MARTELL

A younger prince of Dorne, Oberyn Martell was also a fierce fighter who earned the nickname the "Red Viper." He spent time in the Citadel but quit his studies before earning a full set of links. Prince Oberyn acted as Tyrion Lannister's champion during Tyrion's trial by combat for the murder of King Joffrey. He was killed by Gregor Clegane.

ELLARIA SAND

Born a bastard of Dorne, Ellaria traveled to King's Landing with her lover, Prince Oberyn Martell, and witnessed his death at the hands of the Mountain. Unable to convince Prince Doran to take revenge against the Lannisters, she recruited the Sand Snakes, Oberyn's bastard daughters, to take matters into their own hands. While Doran put an end to her plan to kidnap Myrcella Baratheon, Ellaria managed to poison the princess with a fatal kiss.

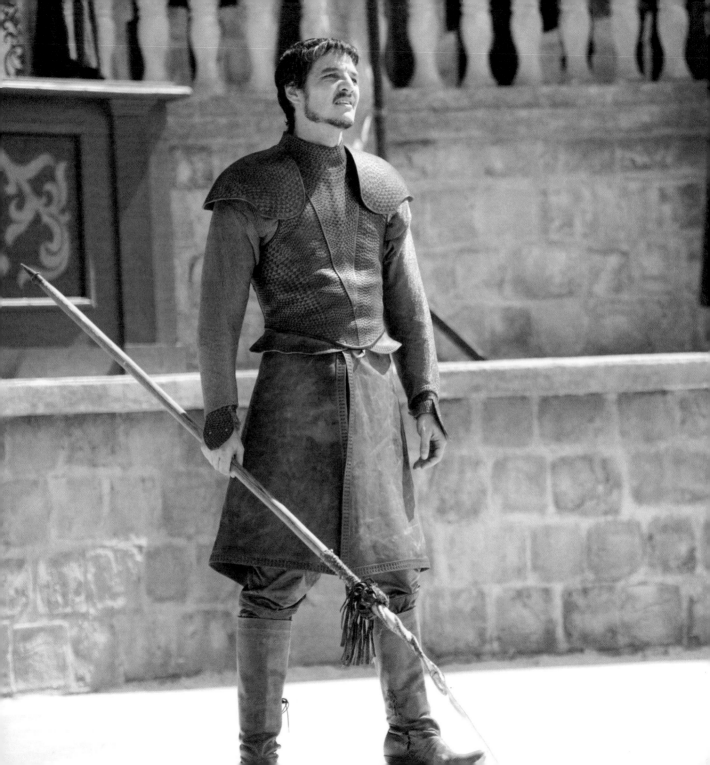

THE FAMILY

TRYSTANE MARTELL

A prince of Dorne and heir to Doran Martell, Trystane was engaged to Myrcella Baratheon, whom he genuinely loved. He is sailing with Jaime Lannister back to King's Landing to take the seat on the Small Council previously held by his uncle, Oberyn Martell.

TYENE SAND

Daughter of Oberyn Martell with Ellaria Sand, Tyene is the youngest of the Sand Snakes. Tyene is proficient with daggers and is fully aligned with her mother's request to avenge Oberyn's death.

NYM SAND

Nym Sand is one of Oberyn's bastard daughters known as the Sand Snakes. Half Dornish and elegant, she uses the whip as her weapon of choice. She also supports Ellaria's quest to avenge Oberyn's death.

OBARA SAND

Obara Sand is the eldest of Oberyn's daughters known as the Sand Snakes. As a child, she chose her father over her peasant mother and is now as dangerous with a spear as he was. Like her sisters, Obara supports Ellaria's quest to avenge Oberyn's death.

AREO HOTAH

The fiercely loyal bodyguard of Prince Doran, Areo is an imposing figure who wields a longaxe with a six-foot shaft.

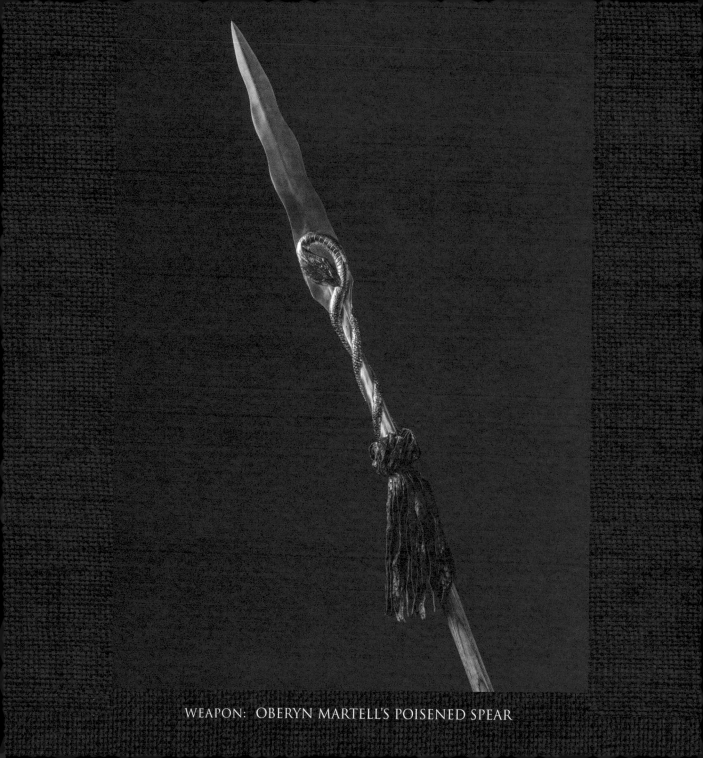

WEAPON: OBERYN MARTELL'S POISENED SPEAR

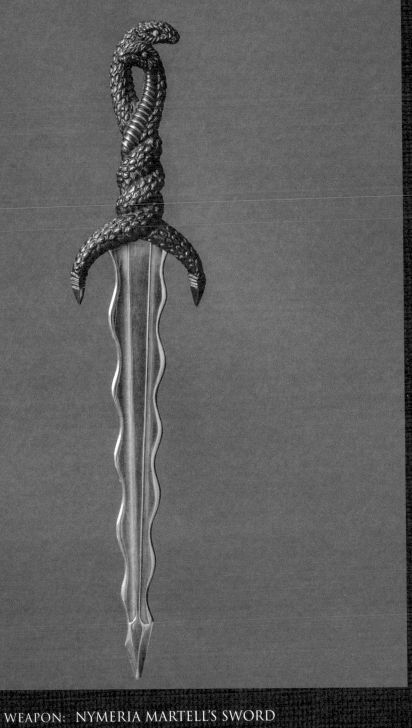

WEAPON: NYMERIA MARTELL'S SWORD

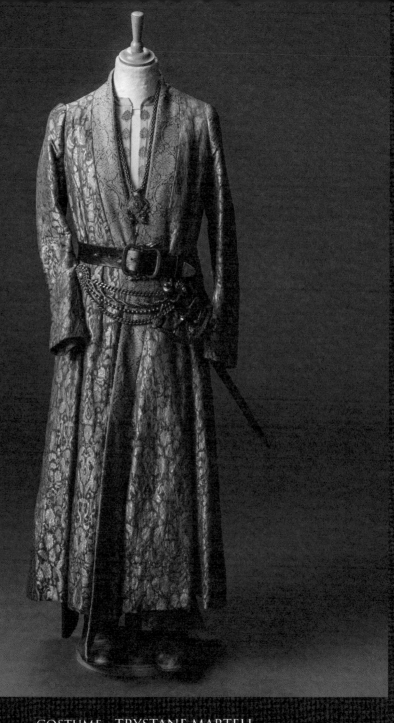

COSTUME: TRYSTANE MARTELL

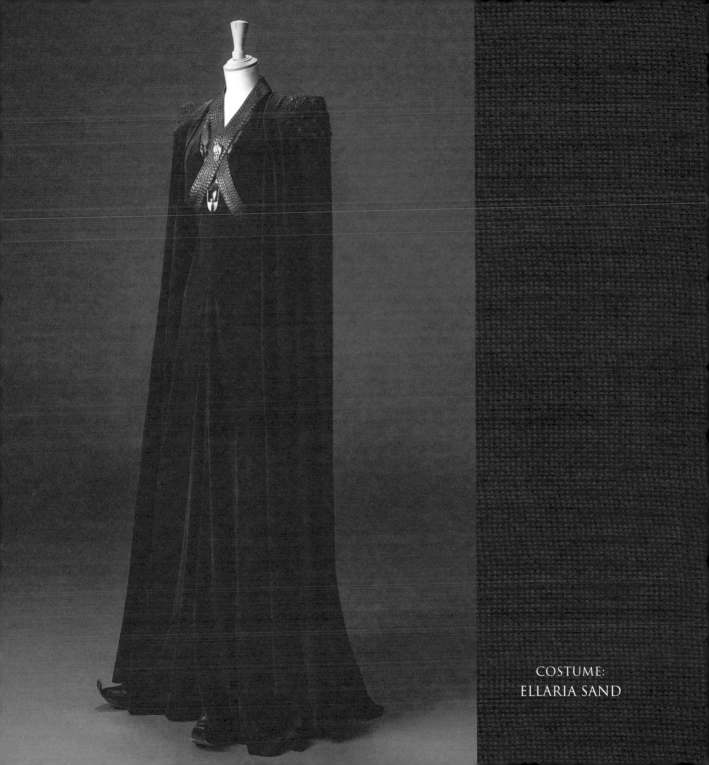

COSTUME:
ELLARIA SAND

"LANNISTER, BARATHEON, STARK, TYRELL. THEY'RE ALL JUST SPOKES ON A WHEEL. THIS ONE'S ON TOP, THEN THAT ONE'S ON TOP AND ON AND ON IT SPINS, CRUSHING THOSE ON THE GROUND."

—DAENERYS TARGARYEN

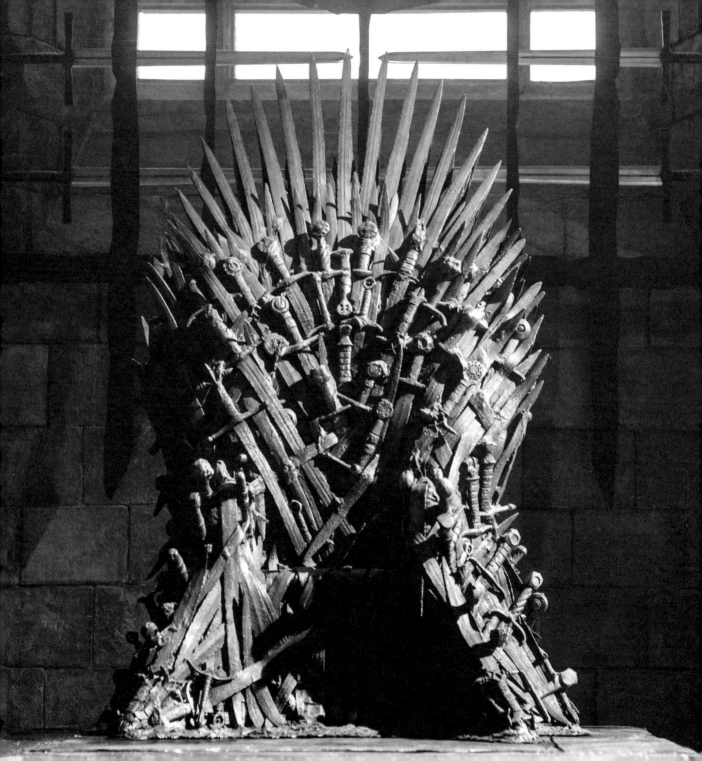